The Future of the Image

The Future
of the Image

\blacklozenge

JACQUES RANCIÈRE

Translated by Gregory Elliott

VERSO
London • New York

This book is supported by the French Ministry of Foreign Affairs
as part of the Burgess programme run by the Cultural Department
of the French Embassy in London. (www.frenchbooknews.com)

First English edition published by Verso 2007
This paperback edition published by Verso 2009
Copyright © Verso 2007
Translation © Gregory Elliott 2007
First published as *Le destin des images*
Copyright © Editions La Fabrique 2003
All rights reserved

3 5 7 9 10 8 6 4

Verso
UK: 6 Meard Street, London W1F 0EG
USA: 20 Jay Street, Suite 1010, Brooklyn, NY 11201
www.versobooks.com

Verso is the imprint of New Left Books

ISBN-13: 978-1-84467-297-4

British Library Cataloguing in Publication Data
A catalogue record for this book is available from the British Library

Library of Congress Cataloging-in-Publication Data
A catalog record for this book is available from the Library of Congress

Typeset in Times by Hewer Text UK Ltd
Printed in the USA by Worldcolor/Fairfield

Contents

Sources of Texts

'The Future of the Image' and 'Sentence, Image, History' were given as talks at the Centre National de la Photographie, at the invitation of Annik Duvillaret, on 31 January 2002 and 24 October 2002.

'Painting in the Text' originated from a talk given on 23 March 1999 at the Akademie Bildenden Künste in Vienna, at the invitation of Eric Alliez and Elisabeth von Samsonow. It also incorporates parts of 'Les énoncés de la rupture', a contribution to *Ruptures: De la discontinuité dans la vie artistique*, edited by Jean Galard (ENSBA/Musée de Louvre, 2002).

'The Surface of Design' was first published under the title 'Les ambivalences du graphisme' in the collective work *Design . . . Graphique?* edited by Annick Lantenois (Ecole régionale des Beaux-Arts de Valance, 2002).

'Are Some Things Unrepresentable?' was first published in No. 36 of *Genre humain*, edited by Jean-Luc Nancy, under the title 'L'art et la mémoire des camps' (Autumn/Winter 2001).

All the texts have been revised for publication here.

1

The Future of the Image

My title might lead readers to anticipate some new odyssey of the image, taking us from the Aurorean glory of Lascaux's paintings to the contemporary twilight of a reality devoured by media images and an art doomed to monitors and synthetic images. But my intention is different. By examining how a certain idea of fate and a certain idea of the image are tied up in the apocalyptic discourses of today's cultural climate, I would like to pose the following question: are we in fact referring to a simple, univocal reality? Does not the term 'image' contain several functions whose problematic alignment precisely constitutes the labour of art? On this basis it will perhaps be possible to reflect on what artistic images are, and contemporary changes in their status, more soundly.

Let us start at the beginning. What is being spoken about, and what precisely are we being told, when it is said that there is no longer any reality, but only images? Or, conversely, that there are no more images but only a reality incessantly representing itself to itself? These two discourses seem to be opposed. Yet we know that they are forever being converted into one another in the name of a rudimentary argument: if there is now nothing but images, there is nothing other than the image. And if there is nothing other than the image, the very notion of the image becomes devoid of content. Several contemporary authors thus contrast the

Image, which refers to an Other, and the Visual, which refers to nothing but itself.

This simple line of argument already prompts a question. That the Same is the opposite of the Other is readily intelligible. Understanding what this Other is is less straightforward. In the first place, by what signs is its presence or absence to be recognized? What allows us to say that the Other is there in one visible form on a screen but not in another? That it is present, for example, in a shot from *Au hasard Balthazar* and not in an episode of *Questions pour un champion*?[1] The response most frequently given by detractors of the 'visual' is this: the television image has no Other by virtue of its very nature. In effect, it has its light in itself, while the cinematic image derives it from an external source. This is summarized by Régis Debray in a book called *Vie et mort de l'image*: 'The image here has its light in-built. It reveals itself. With its source in itself, it becomes in our eyes its own cause. Spinozist definition of God or substance.'[2]

The tautology posited here as the essence of the Visual is manifestly nothing but the tautology of the discourse itself. The latter simply tells us that the Same is same and the Other other. Through the rhetorical play of telescoped, independent propositions, it passes itself off as more than a tautology by identifying the general properties of universals with the characteristics of a technical device. But the technical properties of the cathode tube are one thing and the aesthetic properties of the images we see on the screen are another. The screen precisely lends itself to accommodating the results both of *Questions pour un champion* and of Bresson's camera. It is therefore clear that it is these results which are inherently different. The nature of the amusement television offers us, and of the affects it produces in us, is independent of the fact

that the light derives from the apparatus. And the intrinsic nature of Bresson's images remains unchanged, whether we see the reels projected in a cinema, or through a cassette or disc on our television screen, or a video projection. The Same is not on one side, while the Other is on the other. The set with in-built light and the camera of *Questions pour un champion* place us before a feat of memory and presence of mind that is in itself foreign to them. On the other hand, the film of the film theatre or the cassette of *Au hasard Balthazar* viewed on our screen show us images that refer to nothing else, which are themselves the performance.

THE ALTERITY OF IMAGES

These images refer to nothing else. This does not mean, as is frequently said, that they are intransitive. It means that alterity enters into the very composition of the images, but also that such alterity attaches to something other than the material properties of the cinematic medium. The images of *Au hasard Balthazar* are not primarily manifestations of the properties of a certain technical medium, but operations: relations between a whole and parts; between a visibility and a power of signification and affect associated with it; between expectations and what happens to meet them. Let us look at the beginning of the film. The play of 'images' has already begun when the screen is still dark, with the crystalline notes of a Schubert sonata. It continues, while the credits flash by against a background conjuring up a rocky wall, a wall of dry-stone or boiled cardboard, when braying has replaced the sonata. Then the sonata resumes, overlaid next by a noise of small bells which carries on into the first shot of the film: a little donkey's head sucking at its mother's teat in close-up. A very white hand

then descends along the dark neck of the little donkey, while the camera ascends in the opposite direction to show the little girl whose hand this is, her brother and her father. A dialogue accompanies this action ('We must have it' – 'Give it to us' – 'Children, that's impossible'), without us ever seeing the mouth that utters these words. The children address their father with their backs to us; their bodies obscure his face while he answers them. A dissolve then introduces a shot that shows us the opposite of these words: from behind, in a wide-angled shot, the father and the children come back down leading the donkey. Another dissolve carries us over into the donkey's baptism – another close-up that allows us to see nothing but the head of the animal, the arm of the boy who pours the water, and the chest of the little girl who holds a candle.

In these credits and three shots we have a whole regime of 'imageness' – that is, a regime of relations between elements and between functions. It is first and foremost the opposition between the neutrality of the black or grey screen and the sound. The melody that pursues its direct course in clearly separated notes, and the braying which interrupts it, already convey the tension of the story to come. This contrast is taken up by the visual contrast between a white hand on an animal's black coat and by the separation between voices and faces. In turn, the latter is extended by the link between a verbal decision and its visual contradiction, between the technical procedure of the dissolve, which intensifies the continuity, and the counter-effect that it shows us.

Bresson's 'images' are not a donkey, two children and an adult. Nor are they simply the technique of close-ups and the camera movements or dissolves that enlarge them. They are operations that couple and uncouple the visible and its sig-

nification or speech and its effect, which create and frustrate expectations. These operations do not derive from the properties of the cinematic medium. They even presuppose a systematic distance from its ordinary employment. A 'normal' director would give us some sign, however slight, of the father's change of mind. And he would use a wider angle for the baptism scene, have the camera ascend, or introduce an additional shot in order to show us the expression on the children's faces during the ceremony.

Shall we say that Bresson's fragmentation vouchsafes us, rather the narrative sequence of those who align cinema with the theatre or the novel, the pure images peculiar to this art? But the camera's fixing on the hand that pours the water and the hand that holds the candle is no more peculiar to cinema than the fixing of Doctor Bovary's gaze on Mademoiselle Emma's nails, or of Madame Bovary's gaze on those of the notary's clerk, is peculiar to literature. And the fragmentation does not simply break the narrative sequence. It performs a double operation with respect to it. By separating the hands from the facial expression, it reduces the action to its essence: a baptism consists in words and hands pouring water over a head. By compressing the action into a sequence of perceptions and movements, and short-circuiting any explanation of the reasons, Bresson's cinema does not realize a peculiar essence of the cinema. It forms part of the novelistic tradition begun by Flaubert: an ambivalence in which the same procedures create and retract meaning, ensure and undo the link between perceptions, actions and affects. The wordless immediacy of the visible doubtless radicalizes its effect, but this radicalism itself works through the operation of the power which separates cinema from the plastic arts and makes it approximate to literature: the power of anticipating an effect the better to displace or contradict it.

The image is never a simple reality. Cinematic images are primarily operations, relations between the sayable and the visible, ways of playing with the before and the after, cause and effect. These operations involve different image-functions, different meanings of the word 'image'. Two cinematic shots or sequences of shots can thus pertain to a very different 'imageness'. Conversely, one cinematic shot can pertain to the same type of imageness as a novelistic sentence or a painting. That is why Eisenstein could look to Zola or Dickens, as to Greco or Piranesi, for models of cinematic montage; and why Godard can compose a eulogy to cinema using Elie Faure's sentences on Rembrandt's painting.

The image in films is thus not opposed to television broad-casting as alterity is to identity. Television broadcasting like-wise has its Other: the effective performance of the set. And cinema also reproduces a constructed performance in front of a camera. It is simply that when we speak of Bresson's images we are not referring to the relationship between what has happened elsewhere and what is happening before our eyes, but to operations that make up the artistic nature of what we are seeing. 'Image' therefore refers to two different things. There is the simple relationship that produces the likeness of an original: not necessarily its faithful copy, but simply what suffices to stand in for it. And there is the interplay of operations that produces what we call art: or precisely an alteration of resemblance. This alteration can take a myriad of forms. It might be the visibility given to brush-strokes that are superfluous when it comes to revealing who is represented by the portrait; an elongation of bodies that expresses their motion at the expense of their proportions; a turn of language that accentuates the expression of a feeling or renders the perception of an idea more complex; a word or a shot in place

of the ones that seemed bound to follow; and so on and so forth.

This is the sense in which art is made up of images, regardless of whether it is figurative, of whether we recognize the form of identifiable characters and spectacles in it. The images of art are operations that produce a discrepancy, a dissemblance. Words describe what the eye might see or express what it will never see; they deliberately clarify or obscure an idea. Visible forms yield a meaning to be construed or subtract it. A camera movement anticipates one spectacle and discloses a different one. A pianist attacks a musical phrase 'behind' a dark screen. All these relations define images. This means two things. In the first place, the images of art are, as such, dissemblances. Secondly, the image is not exclusive to the visible. There is visibility that does not amount to an image; there are images which consist wholly in words. But the commonest regime of the image is one that presents a relationship between the sayable and the visible, a relationship which plays on both the analogy *and* the dissemblance between them. This relationship by no means requires the two terms to be materially present. The visible can be arranged in meaningful tropes; words deploy a visibility that can be blinding.

It might seem superfluous to recall such simple things. But if it is necessary to do so, it is because these simple things are forever being blurred, because the identitarian alterity of resemblance has always interfered with the operation of the relations constitutive of artistic images. To resemble was long taken to be the peculiarity of art, while an infinite number of spectacles and forms of imitation were proscribed from it. In our day, not to resemble is taken for the imperative of art, while photographs, videos and displays of objects similar to everyday ones have taken the place of abstract canvases in

galleries and museums. But this formal imperative of non-resemblance is itself caught up in a singular dialectic. For there is growing disquiet: does not resembling involve renouncing the visible? Or does it involve subjecting its concrete richness to operations and artifices whose matrix resides in language? A counter-move then emerges: what is contrasted with resemblance is not the operativeness of art, but material presence, the spirit made flesh, the absolutely other which is also absolutely the same. 'The Image will come at the Resurrection', says Godard: the Image – that is, the 'original image' of Christian theology, the Son who is not 'similar' to the Father but partakes of his nature. We no longer kill each other for the *iota* that separates this image from the other. But we continue to regard it as a promise of flesh, capable of dispelling the simulacra of resemblance, the artifices of art, and the tyranny of the letter.

IMAGE, RESEMBLANCE, HYPER-RESEMBLANCE

In short, the image is not merely double; it is triple. The artistic image separates its operations from the technique that produces resemblances. But it does so in order to discover a different resemblance en route – a resemblance that defines the relation of a being to its provenance and destination, one that rejects the mirror in favour of the immediate relationship between progenitor and engendered: direct vision, glorious body of the community, or stamp of the thing itself. Let us call it hyper-resemblance. Hyper-resemblance is the original resemblance, the resemblance that does not provide the replica of a reality but attests directly to the elsewhere whence it derives. This hyper-resemblance is the alterity our contempor-

aries demand from images or whose disappearance, together with the image, they deplore. To tell the truth, however, it never disappears. It never stops slipping its own activity into the very gap that separates the operations of art from the techniques of reproduction, concealing its rationale in that of art or in the properties of machines of reproduction, even if it means sometimes appearing in the foreground as the ultimate rationale of both.

It is what emerges in the contemporary stress on distinguishing the genuine image from its simulacrum on the basis of the precise mode of its material reproduction. Pure form is then no longer counter-posed to bad image. Opposed to both is the imprint of the body which light registers inadvertently, without referring it either to the calculations of painters or the language games of signification. Faced with the image *causa sui* of the television idol, the canvas or screen is made into a vernicle on which the image of the god made flesh, or of things at their birth, is impressed. And photography, formerly accused of opposing its mechanical, soulless simulacra to the coloured flesh of painting, sees its image inverted. Compared with pictorial artifices, it is now perceived as the very emanation of a body, as a skin detached from its surface, positively replacing the appearances of resemblance and defeating the efforts of the discourse that would have it express a meaning.

The imprint of the thing, the naked identity of its alterity in place of its imitation, the wordless, senseless materiality of the visible instead of the figures of discourse – this is what is demanded by the contemporary celebration of the image or its nostalgic evocation: an immanent transcendence, a glorious essence of the image guaranteed by the very mode of its material production. Doubtless no one has expressed this view

better than the Barthes of *Camera Lucida*, a work that ironi-
cally has become the bible of those who wish to think about
photographic art, whereas it aims to show that photography is
not an art. Against the dispersive multiplicity of the operations
of art and games of signification, Barthes wants to assert the
immediate alterity of the image – that is, in the strict sense, the
alterity of the One. He wants to establish a direct relationship
between the indexical nature of the photographic image and
the material way it affects us: the *punctum*, the immediate
pathetic effect that he contrasts with the *studium*, or the
information transmitted by the photograph and the meanings
it receives. The *studium* makes the photograph a material to be
decoded and explained. The *punctum* immediately strikes us
with the affective power of the *that was*: *that* – i.e. the entity
which was unquestionably in front of the aperture of the
camera obscura, whose body has emitted radiation, captured
and registered by the black chamber, which affects us here and
now through the 'carnal medium' of light 'like the delayed rays
of a star'.[3]

It is unlikely that the author of *Mythologies* believed in the
para-scientific phantasmagoria which makes photography a
direct emanation of the body displayed. It is more plausible
that this myth served to expiate the sin of the former mythol-
ogist: the sin of having wished to strip the visible world of its
glories, of having transformed its spectacles and pleasures into
a great web of symptoms and a seedy exchange of signs. The
semiologist repents having spent much of his life saying: Look
out! What you are taking for visible self-evidence is in fact an
encoded message whereby a society or authority legitimates
itself by naturalizing itself, by rooting itself in the obviousness
of the visible. He bends the stick in the other direction by
valorizing, under the title of *punctum*, the utter self-evidence of

the photograph, consigning the decoding of messages to the platitude of the *studium*.

But the semiologist who read the encoded message of images and the theoretician of the *punctum* of the wordless image base themselves on the same principle: a principle of reversible equivalence between the silence of images and what they say. The former demonstrated that the image was in fact a vehicle for a silent discourse which he endeavoured to translate into sentences. The latter tells us that the image speaks to us precisely when it is silent, when it no longer transmits any message to us. Both conceive the image as speech which holds its tongue. The former made its silence speak; the latter makes this silence the abolition of all chatter. But both play on the same inter-convertibility between two potentialities of the image: the image as raw, material presence and the image as discourse encoding a history.

FROM ONE REGIME OF 'IMAGENESS' TO ANOTHER

Yet such duplicity is not self-evident. It defines a specific regime of 'imageness', a particular regime of articulation between the visible and the sayable – the one in which photography was born and which has allowed it to develop as a production of resemblance and art. Photography did not become an art because it employed a device opposing the imprint of bodies to their copy. It became one by exploiting a double poetics of the image, by making its images, simultaneously or separately, two things: the legible testimony of a history written on faces or objects and pure blocs of visibility, impervious to any narrativization, any intersection of meaning. This double poetics of the image as cipher of a history

written in visible forms and as obtuse reality, impeding meaning and history, was not invented by the device of the camera obscura. It was born before it, when novel writing redistributed the relations between the visible and the sayable that were specific to the representative regime in the arts and which were exemplified by dramatic speech.

For the representative regime in the arts is not the regime of resemblance to which the modernity of a non-figurative art, or even an art of the unrepresentable, is opposed. It is the regime of a certain alteration of resemblance – that is, of a certain system of relations between the sayable and the visible, between the visible and the invisible. The idea of the pictorial character of the poem involved in the famous *Ut pictura poesis* defines two essential relations. In the first place, by way of narration and description words make something visible, yet not present, seen. Secondly, words make seen what does not pertain to the visible, by reinforcing, attenuating or dissimulating the expression of an idea, by making the strength or control of an emotion felt. This dual function of the image assumes an order of stable relations between the visible and invisible – for example, between an emotion and the linguistic tropes that express it, but also the expressive traits whereby the hand of the artist translates the emotion and transposes the tropes. We might refer here to Diderot's demonstration in his *Lettre sur les sourds-muets*: alter the meaning of a word in the lines Homer gives the dying Ajax and the distress of a man who asked only to die in the sight of the gods becomes the defiance of a rebel who faces up to them when dying. The engravings added to the text supply the evidence to readers, who see the alteration not only in the expression on Ajax's face, but also in the way he holds his arms and the very posture of his body. Change one word and you have a

different emotion, whose alteration can and must be exactly transcribed by the designer.[4]

The break with this system does not consist in painting white or black squares rather than the warriors of antiquity. It does not even consist, as the modernist vulgate would have it, in the fact that any correspondence between the art of words and the art of visible forms comes undone. It consists in the fact that words and forms, the sayable and the visible, the visible and the invisible, are related to one another in accordance with new procedures. In the new regime – the aesthetic regime in the arts, which was constituted in the nineteenth century – the image is no longer the codified expression of a thought or feeling. Nor is it a double or a translation. It is a way in which things themselves speak and are silent. In a sense, it comes to lodge at the heart of things as their silent speech.

Silent speech is to be taken in two senses. In the first, the image is the meaning of things inscribed directly on their bodies, their visible language to be decoded. Thus, Balzac places us before the lizards, the lopsided beams, and half-ruined sign in which the history of the *Maison du chat qui pelote* is read; or shows us the unfashionable spencer of *Cousin Pons*, which encapsulates a period of history, a social destiny, and an individual fate. Silent speech, then, is the eloquence of the very thing that is silent, the capacity to exhibit signs written on a body, the marks directly imprinted by its history, which are more truthful than any discourse proffered by a mouth.

But in a second sense the silent speech of things is, on the contrary, their obstinate silence. Contrasting with Cousin Pons's eloquent spencer is the silent discourse of another novelistic sartorial accessory – Charles Bovary's hat, whose ugliness possesses a profundity of silent expression like the face of an imbecile. The hat and its owner here simply exchange

their imbecility, which is then no longer the characteristic of a person or a thing, but the very status of the relationship of indifference between them, the status of 'dumb' art that makes of this imbecility – this incapacity for an adequate transfer of significations – its very potency.

Accordingly, there is no reason to contrast the art of images with goodness knows not what intransitivity of the poem's words or the painting's brush-strokes. It is the image itself that has changed and art which has become a displacement between two image-functions – between the unfolding of inscriptions carried by bodies and the interruptive function of their naked, non-signifying presence. This dual power of the image was achieved by literary discourse by creating a new relationship with painting. It wished to transpose into the art of words the anonymous existence of genre paintings, which a new eye found to be richer in history than the heroic actions of history paintings obeying the hierarchies and expressive codes laid down by the poetic arts of yesteryear. The façade of the *Maison du chat qui pelote*, or the dining-room discovered by the young painter through his window, take their profusion of detail from recently rediscovered Dutch paintings, offering the silent, intimate expression of a way of life. Conversely, Charles's hat, or the view of the same Charles at his window, open on to the idleness of things and beings, derive the splendour of the insignificant from them.

But the relationship is also inverse: writers 'imitate' Dutch paintings only in as much as they themselves confer a new visibility on these paintings; in as much as their sentences educate a new gaze by teaching people how to read, on the surface of canvases recounting episodes from everyday life, a different history from that of significant or insignificant facts – the history of the pictorial process itself, of the birth of the

image emerging from brush-strokes and flows of opaque matter.

Photography became an art by placing its particular techniques in the service of this dual poetics, by making the face of anonymous people speak twice over – as silent witnesses of a condition inscribed directly on their features, their clothes, their life setting; and as possessors of a secret we shall never know, a secret veiled by the very image that delivers them to us. The indexical theory of photography as the skin peeled off things only serves to put the flesh of fantasy on the Romantic poetics of *everything speaks*, of truth engraved on the very body of things. And the contrast between the *studium* and the *punctum* arbitrarily separates the polarity that causes the aesthetic image constantly to gravitate between hieroglyph and senseless naked presence. In order to preserve for photography the purity of an affect unsullied by any signification offered up to the semiologist or any artifice of art, Barthes erases the very genealogy of the *that was*. By projecting the immediacy of the latter on to the process of mechanical imprinting, he dispels all the mediations between the reality of mechanical imprinting and the reality of the affect that make this affect open to being experienced, named, expressed.

Erasing the genealogy that renders our 'images' material and conceivable; erasing the characteristics that lead to something in our time being experienced by us as art, so as to keep photography free of all art – such is the rather heavy price to be paid for the desire to liberate the pleasure of images from the sway of semiology. What the simple relationship between mechanical impression and the *punctum* erases is the whole history of the relations between three things: the images of art, the social forms of imagery, and the theoretic procedures of criticism of imagery.

Indeed, the point in the nineteenth century at which artistic images were redefined in a mobile relationship between brute presence and encoded history was also the moment when a major trade in collective imagery was created, when the forms of an art developed that was devoted to a set of functions at once dispersed and complementary: giving members of a 'society' with uncertain reference-points the means of seeing and amusing themselves in the form of defined types; creating around market products a halo of words and images that made them desirable; assembling, thanks to mechanical presses and the new procedure of lithography, an encyclopaedia of the shared human inheritance: remote life-forms, works of art, popularized bodies of knowledge. The point at which Balzac makes decoding signs written on stone, clothes and faces the motor of novelistic action, and when art critics begin to see a chaos of brush-strokes in representations of the Dutch bourgeoisie of the golden age, is also the time when the *Magasin pittoresque*, and the physiognomies of the student, the lorette, the smoker, the grocer and every imaginable social type, are launched. It is a period that witnesses an unlimited proliferation of the vignettes and little tales in which a society learns to recognize itself, in the double mirror of significant portraits and insignificant anecdotes that form the metonymies of a world, by transposing the artistic practices of the image/hieroglyph and the suspensive image into the social negotiation of resemblances. Balzac and a number of his peers had no hesitation about engaging in this exercise, ensuring the two-way relationship between the work of literature's images and manufacturing the vignettes of collective imagery.

The moment of this new exchange between artistic images and commerce in social imagery is also that of the formation of the components of the major hermeneutics which sought to

apply the procedures of surprise and decoding initiated by the new literary forms to the flood of social and commercial images. It is the moment when Marx teaches us to decipher the hieroglyphics written on the seemingly a-historical body of the commodity and to penetrate into the productive hell concealed by the words of economics, just as Balzac taught us to decipher a history on a wall or an outfit and enter the underground circles that contain the secret of social appearances. Thereafter, summarizing a century's literature, Freud will teach us how to find in the most insignificant details the key to a history and the formula of a meaning, even if it originates in some irreducible non-sense.

Thus was solidarity forged between the operations of art, the forms of imagery, and the discursiveness of symptoms. It became more complex as the vignettes of pedagogy, the icons of the commodity, and the disused shop windows lost their use-value and exchange-value. For by way of compensation they then received a new image-value, which is nothing other than the twofold power of *aesthetic* images: the inscription of the signs of a history and the affective power of sheer presence that is no longer exchanged for anything. On this dual basis, these disused objects and icons came at the time of Dadaism and Surrealism to populate the poems, canvases, montages and collages of art, representing therein both the derision of a society X-rayed by Marxist analysis and the absolute of desire discovered in the writings of Dr Freud.

THE END OF IMAGES IS BEHIND US

What might then properly be called the fate of the image is the fate of this logical, paradoxical intertwining between the operations of art, the modes of circulation of imagery, and

the critical discourse that refers the operations of the one and the forms of the other to their hidden truth. It is this inter-twining of art and non-art, of art, commodities and discourse, which contemporary mediological discourse seeks to efface, intending by the latter, over and above the discipline that professes itself such, the set of discourses that would deduce the forms of identity and alterity peculiar to images from the properties of apparatuses of production and diffusion. What the simple contrasts between the image and the visual, or the *punctum* and the *studium*, propose is the mourning for a certain phase of this intertwinement – that of semiology as critical thinking about images. The critique of images, as illustrated in exemplary fashion by the Barthes of *Mythologies*, was a mode of discourse that tracked the messages of commodities and power hidden in the innocence of media and advertising imagery or in the pretension of artistic autonomy. This dis-course was itself at the heart of an ambiguous mechanism. On the one hand, it wished to aid art's efforts to free itself of imagery, to achieve control over its own operations, over its power to subvert political and commodity domination. On the other, it seemed to chime with a political consciousness aiming at something beyond, where art forms and life forms would no longer be bound together by the equivocal forms of imagery, but tend to be directly identified with one another.

But the mourning declared for this system seems to forget that it was itself a form of mourning for a certain programme: the programme of a certain end of images. For the 'end of images' is not some mediatic or mediumistic catastrophe, to counter which we need today to restore goodness knows not what transcendence enclosed in the very process of chemical printing and threatened by the digital revolution. Instead, the end of images is a historical project that lies behind us, a vision

of the modern development of art that obtained between the 1880s and the 1920s, between the time of Symbolism and that of Constructivism. In fact, these were the years that witnessed the assertion in a whole variety of ways of the project of an art released from images – that is, released not simply from old representation, but from the new tension between naked presence and the writing of history on things, and released at the same time from the tension between the operations of art and social forms of resemblance and recognition. This project took two major forms, which on more than one occasion were combined: pure art, conceived as art whose results no longer compose images, but directly realize the idea in self-sufficient material form; or art that is realized by abolishing itself, art which abolishes the distance of the image so as to identify its procedures with the forms of a whole life in action, no longer separating art from work or politics.

The first idea found precise formulation in Mallarmé's poetics, as summarized in a famous sentence of his article on Wagner: 'The Moderns regard it as beneath them to imagine. But expert in the use of the arts, they expect each one to lead them to the point where a special power of illusion explodes and then they consent.'[5] This formula proposes an art entirely separate from the social commerce of imagery – of the universal reportage of newspapers or the mechanism of recognition in reflection of bourgeois theatre. It proposes an art of performance, symbolized by the self-vanishing, luminous trace of the firework or the art of a dancer who, as Mallarmé puts it, is not a woman and does not dance, but simply traces the form of an idea with her 'illiterate' feet – or even without her feet, if we think of the art of Loïe Fuller, whose 'dance' consists in the folding and unfolding of a dress lit up by the play of spotlights. To the same project belongs the theatre

dreamt of by Edward Gordon Craig: a theatre that would no longer stage 'pieces' but create its own works – works possibly without words, as in the 'theatre of motion' where the action consists exclusively in the movement of mobile elements constituting what was once called the set of the drama. It is also the meaning of the clear contrast formulated by Kandinsky: on the one hand, the typical art display given over in fact to the imagery of a world, where the portrait of Councillor N and Baron X are placed side by side with a flight of ducks or calves napping in the shade; on the other, an art whose forms are the expression in coloured signs of an internal, conceptual necessity.

To illustrate the second form, we might think of the works and programmes of the Simultaneist, Futurist and Constructivist age: painting as conceived by Boccioni, Balla or Delaunay, whose plastic dynamism embraces the accelerated rhythms and metamorphoses of modern life; Futurist poetry, in synch with the speed of cars or the rattle of machine-guns; dramaturgy à la Meyerhold, inspired by the pure performances of the circus or inventing forms of bio-mechanics in order to homogenize theatrical interactions with the rhythms of socialist production and construction; cinema with Vertov's eye-machine, rendering all machines synchronous – the little machines of the human animal's arms and legs and big machines with their turbines and pistons; a pictorial art of Suprematist pure forms, homogenous with the architectural construction of the forms of a new life; a graphic art *à la* Rodchenko, conferring the same geometrical dynamism on the letters of transmitted messages and the forms of represented aircraft, in tune with the dynamism of the builders and pilots of Soviet planes as with that of the builders of socialism.

Both forms propose to abolish the mediation of the image –

that is, not only resemblance but also the power of operations of decoding and suspension – just as they do the interaction between the operations of art, the commerce of images, and the labour of exegesis. To abolish this mediation was to realize the immediate identity of act and form. It was on this common programme that the two figures of pure art – imageless art – and the becoming-life of art – its becoming non-art – were able to intersect in the 1910s and 1920s; that Symbolist and Suprematist artists could join Futurist or Constructivist denigrators of art in identifying the forms of an art which was purely art with the forms of a new life abolishing the very specificity of art. This end of images – the only one to have been rigorously thought through and pursued – lies behind us, even if architects, urban designers, choreographers, or people who work in theatre sometimes pursue the dream in a minor key. It ended when the authorities to whom this sacrifice of images was offered made it clear that they wanted nothing to do with constructor-artists, that they themselves were taking care of construction, and required of artists nothing but precisely images, understood in a narrowly defined sense: illustrations putting flesh on their programmes and slogans.

The distance of the image then recovered its prerogatives in the Surrealist absolutization of the *explosante fixe* or in the Marxist critique of appearances. Mourning for the 'end of images' was already expressed by the energy devoted by the semiologist to pursuing the messages hidden in images, so as to purify both the surfaces of inscription of art forms and the consciousness of the agents of future revolutions. Surfaces to purify and consciousnesses to educate were the *membra disjecta* of 'imageless' identity, of the lost identity between art forms and life forms. Like all forms of work, the labour of mourning is tiring. And the time came when the semiologist

discovered that the lost pleasure of images is too high a price to pay for the benefit of forever transforming mourning into knowledge. Especially when this knowledge itself loses its credibility, when the real movement of history that guaranteed the traversal of appearances itself proved to be an appearance. The complaint is then no longer that images conceal secrets which are no longer such to anyone, but, on the contrary, that they no longer hide anything. While some start up a prolonged lamentation for the lost image, others reopen their albums to rediscover the pure enchantment of images – that is, the mythical identity between the identity of the *that* and the alterity of the *was*, between the pleasure of pure presence and the bite of the absolute Other.

But the three-way interaction between the social production of resemblances, artistic operations of dissemblance, and the discursiveness of symptoms cannot be reduced to the simple beat of the pleasure principle and the death drive. Evidence of this, perhaps, is the tri-partition presented to us today by exhibitions devoted to 'images', but also the dialectic that affects each type of image and mixes its legitimations and powers with those of the other two.

NAKED IMAGE, OSTENSIVE IMAGE, METAMORPHIC IMAGE

The images exhibited by our museums and galleries today can in fact be classified into three major categories. First of all, there is what might be called the naked image: the image that does not constitute art, because what it shows us excludes the prestige of dissemblance and the rhetoric of exegeses. Thus, a recent exhibition entitled *Mémoires des camps* devoted one of its sections to photographs taken during the discovery of the

Nazi camps. The photographs were often signed by famous names – Lee Miller, Margaret Bourke-White, and so on – but the idea that brought them together was the trace of history, of testimony to a reality that is generally accepted not to tolerate any other form of presentation.

Different from the naked image is what I shall call the ostensive image. This image likewise asserts its power as that of sheer presence, without signification. But it claims it in the name of art. It posits this presence as the peculiarity of art faced with the media circulation of imagery, but also with the powers of meaning that alter this presence: the discourses that present and comment on it, the institutions that display it, the forms of knowledge that historicize it. This position can be encapsulated in the title of an exhibition recently organized at the Brussels Palais des Beaux-Arts by Thierry de Duve to exhibit 'one hundred years of contemporary art': *Voici*. The affect of the *that was* is here apparently referred to the identity without residue of a presence of which 'contemporaneity' is the very essence. The obtuse presence that interrupts histories and discourses becomes the luminous power of a face-to-face: *facingness*, as the organizer puts it, obviously contrasting this notion with Clement Greenberg's *flatness*. But the very contrast conveys the meaning of the operation. Presence opens out into presentation of presence. Facing the spectator, the obtuse power of the image as being-there-without-reason becomes the radiance of a face, conceived on the model of the icon, as the gaze of divine transcendence. The works of the artists – painters, sculptors, video-makers, installers – are isolated in their sheer haeccity. But this haeccity immediately splits in two. The works are so many icons attesting to a singular mode of material presence, removed from the other ways in which ideas and intentions organize the data of sense experience. 'Me

voici', 'Nous voici', 'Vous voici' – the three rubrics of the exhibition – make them witness to an original co-presence of people and things, of things between themselves, and of people between themselves. And Duchamp's tireless urinal once again does service, via the pedestal on which Stieglitz photographed it. It becomes a display of presence making it possible to identify the dissemblances of art with the interactions of hyper-resemblance.

Contrasting with the ostensive image is what I shall call the metamorphic image. Its power as art can be summarized in the exact opposite of *Voici*: the *Voilà* that recently gave its title to an exhibition at the Musée d'art moderne de la Ville de Paris, sub-titled 'Le monde dans la tête'. This title and sub-title involve an idea of the relations between art and image that much more broadly inspires a number of contemporary ex-hibitions. According to this logic, it is impossible to delimit a specific sphere of presence isolating artistic operations and products from forms of circulation of social and commercial imagery and from operations interpreting this imagery. The images of art possess no peculiar nature of their own that separates them in stable fashion from the negotiation of resemblances and the discursiveness of symptoms. The labour of art thus involves playing on the ambiguity of resemblances and the instability of dissemblances, bringing about a local reorganization, a singular rearrangement of circulating images. In a sense the construction of such devices assigns art the tasks that once fell to the 'critique of images'. Only this critique, left to the artists themselves, is no longer framed by an autonomous history of forms or a history of deeds changing the world. Thus art is led to query the radicalism of its powers, to devote its operations to more modest tasks. It aims to play with the forms and products of imagery, rather than carry out

their demystification. This oscillation between two attitudes was evident in a recent exhibition, presented in Minneapolis under the title 'Let's entertain' and in Paris as *Au-delà du spectacle*. The American title invited visitors both to play the game of an art freed from critical seriousness and to mark a critical distance from the leisure industry. For its part, the French title played on the theorization of the game as the active opposite of the passive spectacle in the texts of Guy Debord. Spectators thus found themselves called upon to accord Charles Ray's merry-go-round or Maurizio Catelan's giant table football set their metaphorical value and to take a playful semi-distance from the media images, disco sounds or commercial mangas reprocessed by other artists.

The device of the installation can also be transformed into a theatre of memory and make the artist a collector, archivist or window-dresser, placing before the visitor's eyes not so much a critical clash of heterogeneous elements as a set of testimonies about a shared history and world. Thus the exhibition *Voilà* aimed to recap a century and illustrate the very notion of a century, by bringing together, *inter alia*, Hans-Peter Feldmann's photographs of one hundred people aged 0–100, Christian Boltanski's installation of telephone subscribers, Alighiero and Boetti's *720 Letters from Afghanistan*, or the Martins' room devoted by Bertrand Lavier to exhibiting 50 canvases linked only by the family name of their authors.

The unifying principle behind these strategies clearly seems to be to bring about, on a material that is not specific to art and often indistinguishable from a collection of utilitarian objects or a projection of forms of imagery, a double metamorphosis, corresponding to the dual nature of the *aesthetic* image: the image as cipher of history and the image as interruption. On the one hand, it involves transforming the targeted, intelligent

productions of imagery into opaque, stupid images, interrupting the media flow. On the other, it involves reviving dulled utilitarian objects or the indifferent images of media circulation, so as to create the power of the traces of a shared history contained in them. Installation art thus brings into play the metamorphic, unstable nature of images. The latter circulate between the world of art and the world of imagery. They are interrupted, fragmented, reconstituted by a poetics of the witticism that seeks to establish new differences of potentiality between these unstable elements.

Naked image, ostensive image, metaphorical image: three forms of 'imageness', three ways of coupling or uncoupling the power of showing and the power of signifying, the attestation of presence and the testimony of history; three ways, too, of sealing or refusing the relationship between art and image. Yet it is remarkable that none of these three forms thus defined can function within the confines of its own logic. Each of them encounters a point of undecidability in its functioning that compels it to borrow something from the others.

This is already true of the image that seems best able, and most obliged, to guard against it – the 'naked' image intent solely on witnessing. For witnessing always aims beyond what it presents. Images of the camps testify not only to the tortured bodies they do show us, but also to what they do not show: the disappeared bodies, obviously, but above all the very process of annihilation. The shots of the reporters from 1945 thus need to be viewed in two different ways. The first perceives the violence inflicted by invisible human beings on other human beings, whose suffering and exhaustion confront us and suspend any aesthetic appreciation. The second perceives not violence and suffering, but a process of de-humanization, the disappearance of the boundaries between the human,

animal and mineral. Now, this second view is itself the product of an aesthetic education, of a certain idea of the image. A photograph by Georges Rodger, displayed at the *Mémoires des camps* exhibition, shows us the back of a corpse whose head we cannot see, carried by an SS prisoner whose bowed head shields his face from our eyes. This horrendous assemblage of two truncated bodies presents us with an exemplary image of the common de-humanization of victim and executioner. But it does so only because we see it with eyes that have already contemplated Rembrandt's skinned ox and all the forms of representation which have equated the power of art with obliteration of the boundaries between the human and the inhuman, the living and the dead, the animal and the mineral, all alike merged in the density of the sentence or the thickness of the pictorial paste.[6]

The same dialectic characterizes metamorphic images. These images, it is true, are based on a postulate of indiscernibility. They simply set out to displace the representations of imagery, by changing their medium, by locating them in a different mechanism of vision, by punctuating or recounting them differently. But the question then arises: what exactly is produced as a difference attesting to the specific work of artistic images on the forms of social imagery? This was the question behind the disenchanted thoughts of Serge Daney's last texts: have not all the forms of critique, play, and irony that claim to disrupt the ordinary circulation of images been annexed by that circulation? Modern cinema and criticism claimed to interrupt the flow of media and advertising images by suspending the connections between narration and meaning. The freeze-frame that closes Truffaut's *Quatre cent coups* was emblematic of this suspension. But the brand thus stamped on the image ultimately serves the cause of the brand

image. The procedures of cutting and humour have themselves become the stock-in-trade of advertising, the means by which it generates both adoration of its icons and the positive attitude towards them created by the very possibility of ironizing it.[7]

No doubt the argument is not decisive. By definition, what is undecidable can be interpreted in two ways. But it is then necessary discreetly to draw on the resources of the opposite logic. For the ambiguous montage to elicit the freedom of the critical or ludic gaze, the encounter must be organized in accordance with the logic of the ostensive face-to-face, representing advertising images, disco sounds, or television sequences in the space of the museum, isolated behind a curtain in small dark booths that give them the aura of the work damming the flood of communication. Even so, the effect is never guaranteed, because it is often necessary to place a small card on the door of the booth making it clear to viewers that, in the space they are about to enter, they will learn anew how to see and to put the flood of media messages that usually captivates them at a distance. Such exorbitant power attributed to the properties of the device itself corresponds to a rather simplistic view of the poor morons of the society of the spectacle, bathing contentedly in a flood of media images. The interruptions, derivations and reorganizations that alter the circulation of images less pretentiously have no sanctuary. They occur anywhere and at any time.

But it is doubtless the metamorphoses of the ostensive image that best express the contemporary dialectic of images. For here it proves decidedly difficult to furnish the appropriate criteria for discerning the proclaimed face-to-face, for making presence present. Most of the works put on the pedestal of *Voici* cannot in any way be distinguished from those that

contribute to the documentary displays of *Voilà*. Portraits of stars by Andy Warhol, documents from the mythical section of the Aigles du Musée by Marcel Broodthaers, an installation by Josephy Beuys of a batch of commodities from the ex-GDR, Christian Boltanksi's family album, Raymond Hains's stripped posters, or Pistoletto's mirrors – these scarcely seem conducive to extolling the undiluted presence of *Voici*.

Here too it is then necessary to draw on the opposite logic. The supplement of exegetical discourse proves necessary in order to transform a ready-made by Duchamp into a mystical display or a sleek parallelepiped by Donald Judd into a mirror of intersecting relations. Pop images, neo-realist décollages, monochrome paintings, or minimalist sculptures must be placed under the common authority of a primal scene, occupied by the putative father of pictorial modernity: Manet. But the father of modern painting must himself be placed under the authority of the Word made flesh. His modernism and that of his descendants are indeed defined by Thierry de Duve on the basis of a painting from his 'Spanish' period – *Christ mort soutenu par les anges* – inspired by a canvas of Ribalta's. Unlike his model, Manet's dead Christ has his eyes open and is facing the spectator. He is thus an allegory for the task of substitution assigned painting by the 'death of God'. The dead Christ comes back to life in the pure immanence of pictorial presence.[8] This pure presence is not that of art, but instead of the redeeming Image. The ostensive image celebrated by the *Voici* exhibition is the flesh of material presence raised, in its very immediacy, to the rank of absolute Idea. On this basis, ready-mades and Pop images in sequence, minimalist sculptures or fictional museums, are construed in advance in the tradition of icons and the religious economy of the Resurrection. But the demonstration is obviously double-

edged. The Word is only made flesh through a narrative. An additional operation is always required to transform the products of artistic operations and meaning into witnesses of the original Other. The art of *Voici* must be based on what it refused. It needs to be presented discursively to transform a 'copy', or a complex relationship between the new and the old, into an absolute origin.

Without a doubt Godard's *Histoire(s) du cinéma* affords the most exemplary demonstration of this dialectic. The film-maker places his imaginary Museum of cinema under the sign of the Image that is to come at the Resurrection. His words counter-pose to the deathly power of the Text the living force of the Image, conceived as a cloth of Veronica on which the original face of things is imprinted. To Alfred Hitchcock's obsolete stories they oppose the pure pictorial presence re-presented by the bottles of Pommard in *Notorious*, the wind-mill's sails in *Foreign Correspondent*, the bag in *Marnie*, or the glass of milk in *Suspicion*. I have shown elsewhere how these pure icons had themselves to be removed by the artifice of montage, diverted from their arrangement by Hitchcock, so as to be reintegrated into a pure kingdom of images by the fusing power of video superimposition.[9] The visual production of iconic pure presence, claimed by the filmmaker's discourse, is itself only possible by virtue of the work of its opposite: the Schlegelian poetics of the witticism that invents between fragments of films, news strips, photos, reproductions of paintings and other things all the combinations, distances or approximations capable of eliciting new forms and mean-ings. This assumes the existence of a boundless Store/Library/ Museum where all films, texts, photographs and paintings coexist; and where they can all be broken up into elements each of which is endowed with a triple power: the power of

singularity (the *punctum*) of the obtuse image; the educational value (the *studium*) of the document bearing the trace of a history; and the combinatory capacity of the sign, open to being combined with any element from a different sequence to compose new sentence-images *ad infinitum*.

The discourse that would salute 'images' as lost shades, fleetingly summoned from the depths of Hell, therefore seems to stand up only at the price of contradicting itself, transforming itself into an enormous poem establishing unbounded communication between arts and mediums, artworks and illustrations of the world, the silence of images and their eloquence. Behind the appearance of contradiction, we must take a closer look at the interaction of these exchanges.

2

Sentence, Image, History

Godard's *Histoire(s) du cinéma* is governed by two seemingly contradictory principles. The first counter-poses the autonomous existence of the image, conceived as visual presence, to the commercial convention of history and the dead letter of the text. Cézanne's apples, Renoir's bouquets, or the lighter in *Strangers on a Train* attest to the singular power of silent form. This renders the construction of plots inherited from the novelistic tradition, and organized to satisfy the desires of the public and the interests of industry, non-essential. Conversely, the second principle makes these visible presences elements which, like the signs of language, possess a value only by dint of the combinations they authorize: combinations with different visual and sonorous elements, but also sentences and words, spoken by a voice or written on the screen. Extracts from novels or poems, or the titles of films and books, frequently create connections that confer meaning on the images, or rather make the assembled visual fragments 'images' – that is, relations between a visibility and a signification. *Siegfried et le Limousin* – the title of Giraudoux's novel – superimposed on the tanks of the invading German army and on a shot from Fritz Lang's *Nibelungen*, is enough to make this sequence a combined image of the defeat of the French forces in 1940 and of German artists in the face of Nazism, of the ability of literature and cinema to foresee the disasters of their

times and their inability to prevent them. On the one hand, then, the image is valuable as a liberating power, pure form and pure *pathos* dismantling the classical order of organization of fictional action, of *stories*. On the other, it is valuable as the factor in a connection that constructs the figure of a common *history*. On the one hand, it is an incommensurable singularity; while on the other it is an operation of communalization.

WITHOUT A COMMON
TERM OF MEASUREMENT?

The context of an exhibition devoted to the relations between images and words naturally invites us to reflect on this double power placed under the same name of image. This exhibition is called *Sans commune mesure*.[1] Such a title does more than describe the collection of verbal and visual elements presented here. It appears a prescriptive statement, defining the criterion of the 'modernity' of the works. Indeed, it assumes that incommensurability is a distinguishing feature of the art of our time; that the peculiarity of the latter is the gap between material presences and meanings. This declaration itself has a rather long genealogy: the Surrealist valorization of the impossible encounter between umbrella and sewing machine; Benjamin's theorization of the dialectical clash of images and times; Adorno's aesthetic of the contradiction inherent in modern works of art; Lyotard's philosophy of the sublime gap between the Idea and any empirical presentation. The very continuity of this valorization of the incommensurable risks making us indifferent to the relevance of the judgement that includes some particular work in it, but also to the very significance of the terms. Thus, for my part I shall take this title as an *invitation* to reformulate the questions, to ask

ourselves: What precisely does 'without a common term of measurement' mean? With respect to what idea of measurement and what idea of community? Perhaps there are several kinds of incommensurability. Perhaps each of them is itself the bringing into play of a certain form of community.

The apparent contradiction of *Histoire(s) du cinéma* might well enlighten us then on this conflict of measures and communities. I would like to show this starting from a small episode taken from the last part. It is called *Les signes parmi nous*. This title, borrowed from Ramuz, in itself involves a double 'community'. First of all, there is the community between 'signs' and 'us': signs are endowed with a presence and a familiarity that makes them more than tools at our disposal or a text subject to our decoding; they are inhabitants of our world, characters that make up a world for us. Next, there is the community contained in the concept of sign, such as it functions here. Visual and textual elements are in effect conceived together, interlaced with one another, in this concept. There are signs 'among us'. This means that the visible forms speak and that words possess the weight of visible realities; that signs and forms mutually revive their powers of material presentation and signification.

Yet Godard gives this 'common measure' of signs a concrete form that seems to contradict its idea. He illustrates it by heterogeneous visual elements whose connection on the screen is enigmatic, and with words whose relationship to what we see we cannot grasp. Following an extract from *Alexander Nevsky*, an episode begins in which repeated superimposed images, answering one another in twos, impart a unity that is confirmed by the continuity of two texts, which have seemingly been taken from a speech in one instance, from a poem in the other. This small episode seems to be tightly structured by four

visual elements. Two of them are readily identifiable. They belong in fact to the store of significant images of twentieth-century history and cinema. They are, at the beginning of the sequence, the photograph of the little Jewish boy who raises his arms during the surrender of the Warsaw ghetto; and, at the end, a black shadow that sums up all the ghosts and vampires from the Expressionist age of cinema: Murnau's Nosferatu. The same is not true of the two elements with which they are coupled. Superimposed on the image of the child from the ghetto is a mysterious cinematic figure: a young woman who is descending a staircase carrying a candle that outlines her shadow on the wall in spectacular fashion. As for Nosferatu, he bizarrely faces a cinema theatre where an ordinary couple in the foreground is laughing heartily, in the anonymity of a beaming audience revealed by the camera as it moves back.

How should we conceive the relationship between this cinematic chiaroscuro and the extermination of the Polish Jews? Between the good-natured crowd in a Hollywood film and the Carpathian vampire who seems to be orchestrating its pleasure from the stage? The fleeting views of faces and riders that fill out the space scarcely tell us. We then look to the spoken or written words that connect them for some indications. At the end of the episode, these consist in letters that are assembled and disassembled on the screen: *l'ennemi public, le public*. In the middle, they are a poetic text which speaks to us of a sob that rises and subsides. Above all, at the beginning, giving its tonality to the whole episode, we have a text whose oratorical solemnity is accentuated by the muffled, slightly emphatic voice of Godard. This text tells us of a voice by which the orator would like to have been preceded, in which his voice could have been merged. The speaker tells us that he now understands his difficulty in beginning a moment ago. And for

our part we thus understand that the text which introduces the episode is in fact a peroration. It tells us which is the voice that would have enabled him to begin. It is a manner of speaking, obviously: by way of telling us this, he leaves it to another audience to hear – one which precisely does not need to be told it, since the context of the speech suffices to make the fact known to it.

This speech is in fact an acceptance speech – a genre where it is obligatory to eulogize one's deceased predecessor. This can be done more or less elegantly. The orator in question has proved capable of choosing the most elegant way, one that identifies the circumstantial eulogy of the deceased elder with the essential invocation of the anonymous voice which makes speech possible. Such felicities of conception and expression are rare and indicate their author. It is Michel Foucault who is the author of these lines. And the 'voice' thus amplified is that of Jean Hyppolite to whom he succeeded on that day to the chair in the history of systems of thought at the Collège de France.[2]

So it is the peroration of Foucault's inaugural lecture that supplies the link between the images. Godard has positioned it here just as, twenty years earlier in *La Chinoise*, he had introduced another, equally brilliant peroration: the one with which Louis Althusser concluded his most inspired text – the *Esprit* article on the Piccolo Teatro, Bertolazzi et Brecht ('I look back, and I am suddenly and irresistibly assailed by the question . . .').[3] Then it was Guillaume Meister, the activist/ actor played by Jean-Pierre Léaud, who gave literal effect to the words by actually looking back to hammer out the text, looking straight into the eyes of an imaginary interviewer. This pantomime served to represent the verbal power of Maoist discourse over young bodies of Parisian students. Responding

now to this literalization, which is Surrealist in spirit, is an enigmatic relationship between the text and the voice and between the voice and the bodies we see. Instead of Michel Foucault's clear, dry and rather cheerful voice, we hear the serious voice of Godard, filled with a Malraux-style pomposity. This indication therefore leaves us in a state of indecision. How does the lugubrious accent put on this purple passage, which is bound up with an institutional investiture, connect the young woman with the candle and the child from the ghetto, the shades of cinema and the extermination of the Jews? What are the text's words doing in relation to the visual elements? What is the fit between the power of conjunction assumed by montage and the power of disjunction involved in the radical heterogeneity between an unidentified shot of a nocturnal staircase, testimony about the end of the Warsaw ghetto, and the inaugural lecture of a professor at the Collège de France who dealt neither with cinema nor with the Nazi extermination? We can already glimpse here that the common, measurement, and the relationship between them can be stated and conjoined in several ways.

Let us begin at the beginning. Godard's montage assumes the establishment of what some call modernity, but which, in order to avoid the teleologies inherent in temporal markers, I prefer to call the aesthetic regime in art. This presupposed result is the distance taken from a certain form of common measurement – that expressed by the concept of history. History was the 'assemblage of actions' which, since Aristotle, had defined the rationality of the poem. This ancient measurement of the poem according to a schema of ideal causality – connection by necessity or verisimilitude – involved also a certain form of intelligibility of human actions. It is what established a community of signs and a community between 'signs' and 'us': a

combination of elements in accordance with general rules and a community between the intelligence that produced these combinations and sensibilities called upon to experience the pleasure of them. This measurement involved a relationship of subordination between a ruling function – the textual function of intelligibility – and an image-forming function in its service. To form images was to take the thoughts and feelings through which the causal connection was displayed to their highest expression. It was also to create specific affects that strengthened the perception of this connection. This subordination of the 'image' to the 'text' in thinking about poems also founded the correspondence of the arts, under its legislation.

If we take it as given that this hierarchical order has been abolished, that the power of words and the power of the visible have been freed from this common measurement system for two centuries, the question arises: how should we conceive the effect of this uncoupling?

We know the standard reply to this question. This effect is quite simply the autonomy of verbal art, of the art of visible forms, and of all the other arts. Such autonomy was supposedly demonstrated once and for all in the 1760s, by the impossibility of translating into stone the 'visibility' given by Virgil's poem to Laocoon's suffering without rendering the statue repulsive. This absence of common measurement, this registration of the disjunction between registers of expression and therefore between the arts, formulated by Lessing's *Laocoon*, is the common core of the 'modernist' theorization of the aesthetic regime in the arts – a theorization that conceives the break with the representative regime in terms of the autonomy of art and separation between the arts.

This common core can be translated into three versions that I shall summarize in their essentials. There is first of all the

rationalist, optimistic version. What succeeds histories, and the images that were subordinate to them, are forms. It is the power of each specific materiality – verbal, plastic, sonorous or whatever – revealed by specific procedures. This separation between the arts is guaranteed not by the simple fact of the absence of any common term of measurement between words and stone, but by the very rationality of modern societies. Such rationality is characterized by a separation between spheres of existence and of the forms of rationality specific to each of them – a separation that the bond of communicative reason must simply complement. Here we recognize the teleology of modernity that a famous talk by Habermas counter-poses to the perversions of 'post-structuralist' aestheticism, ally of neo-conservatism.

Next there is the dramatic and dialectical version of Adorno. Therein artistic modernity represents the conflict of two separations or, if one likes, two forms of incommensurability. For the rational separation between spheres of existence is in fact the work of a certain reason – the calculative reason of Ulysses which is opposed to the Sirens' song, the reason that separates work and pleasure. The autonomy of artistic forms and the separation between words and forms, music and plastic forms, high art and forms of entertainment then take on a different meaning. They remove the pure forms of art from the forms of aestheticized everyday, market existence that conceal the fracture. They thus make it possible for the solitary tension of these autonomous forms to express the original separation that founds them, to disclose the 'image' of the repressed, and remind us of the need for a non-separated existence.

Finally, we have the pathetic version evinced by Lyotard's last books. The absence of any common measurement is here

called catastrophe. And it is then a question of contrasting not two separations, but two catastrophes. The separation of art is in effect assimilated to the original break of the sublime, to the undoing of any stable relationship between idea and empirical presentation. This incommensurability is itself thought as the mark of the power of the Other, whose denegation in Western reason has generated the dementia of extermination. If modern art must preserve the purity of its separations, it is so as to inscribe the mark of this sublime catastrophe whose inscription also bears witness against the totalitarian catastrophe – that of the genocides, but also that of aestheticized (i.e., in fact, anaesthetized) existence.

How should the disjunctive conjunction of Godard's images be situated vis-à-vis these three representations of the incommensurable? Certainly, Godard sympathizes with the modernist teleology of purity – especially, obviously, in its catastrophist form. Throughout *Histoire(s) du cinéma*, he opposes the redemptive virtue of the image/icon to the original sin that has ruined cinema and its power of witness: submission of the 'image' to the 'text', of the material to 'history'. Yet the 'signs' that he presents to us here are visual elements organized in the form of discourse. The cinema that he recounts to us appears as a series of appropriations of other arts. And he presents it to us in an interlacing of words, sentences and texts, of metamorphosed paintings, of cinematic shots mixed up with news photographs or strips, sometimes connected by musical citations. In short, *Histoire(s) du cinéma* is wholly woven out of those 'pseudometamorphoses', those imitations of one art by another that are rejected by avant-gardist purity. And in this tangle the very notion of image, notwithstanding Godard's iconodulistic declarations, emerges as that of a metamorphic opera-

tiveness, crossing the boundaries between the arts and deny-
ing the specificity of materials.

Thus, the loss of any common term of measurement between
the means of art does not signify that henceforth each remains
in its own sphere, supplying its own measurement. Instead, it
means that any common measurement is now a singular
production and that this production is only possible on con-
dition of confronting, in its radicalism, the measurelessness of
the melange. The fact that the suffering of Virgil's Laocoon
cannot be translated exactly into sculptor's stone does not
entail that words and forms part company; that some artists
devote themselves to the art of words, while others work on the
intervals of time, coloured surfaces, or volumes of recalcitrant
matter. Quite the opposite deduction can possibly be made.
When the thread of history – that is, the common measure-
ment that governs the distance between the art of some and
that of others – is undone, it is not simply the forms that
become analogous; the materialities are immediately mixed.

The mixing of materialities is conceptual before it is real.
Doubtless we had to wait until the Cubist and Dadaist age for
the appearance of words from newspapers, poems or bus
tickets on the canvases of painters; the age of Nam Jun Paik
for the transformation into sculptures of loudspeakers given
over to broadcasting sounds and screens intended for the
reproduction of images; the age of Wodiczko or Pipilloti Rist
for the projection of moving images on to statues of the
Founding Fathers or the arms of chairs; and that of Godard
for the invention of reverse angle shots in a painting by Goya.
But as early as 1830 Balzac could populate his novels with
Dutch paintings and Hugo could transform a book into a
cathedral or a cathedral into a book. Twenty years later,
Wagner could celebrate the carnal union of male poetry

and female music in the same physical materiality; and the prose of the Goncourts could transform the contemporary painter (Decamps) into a stonemason, before Zola transformed his fictional painter Claude Lantier into a window-dresser/installer, pronouncing his most beautiful work to be the ephemeral rearrangement of turkeys, sausages and black puddings in the Quenu *charcuterie*.[4]

As early as the 1820s, a philosopher – Hegel – attracted the well-founded execration of all future modernisms in advance by showing that the separation between spheres of rationality entailed not the glorious autonomy of art and the arts, but the loss of their power of thinking in common, of thinking, producing or expressing something common; and that from the sublime gap invoked there possibly resulted nothing but the 'entertainer's' indefinitely repeated abrupt switch of subject, capable of combining everything with anything. Whether the artists of the subsequent generation read him, did not read him, or read him badly is of little importance. This was the argument to which they replied by seeking the principle of their art not in some term of measurement that would be peculiar to each of them, but on the contrary where any such 'peculiarity' collapses; where all the common terms of measurement that opinions and histories lived on have been abolished in favour of a great chaotic juxtaposition, a great indifferent melange of significations and materialities.

THE SENTENCE-IMAGE
AND THE GREAT PARATAXIS

Let us call this the great parataxis. In Flaubert's time, it could take the form of the collapse of all the systems of rationales for emotions and actions in favour of the vagaries of the indif-

ferent intermixture of atoms. A little dust shining in the sun, a drop of melted snow falling on the moiré silk of a parasol, a blade of foliage on the muzzle of a donkey – these are the tropes of matter that invent love by ranking its rationale with the great absence of any rationale for things. In Zola's time, it is piles of vegetables, *charcuterie*, fish and cheeses in *Le Ventre de Paris*, or the cascades of white cloth set ablaze by the fire of the consummation in *Au Bonheur des dames*. In the time of Apollinaire or Blaise Cendrars, of Boccioni, Schwitters or Varese, it is a world where all the histories have dissolved into sentences, which have themselves dissolved into words, exchangeable with the lines, strokes or 'dynamisms' that any pictorial subject has dissolved into; or with the sound intensities in which the notes of the melody merge with ship horns, car noise, and the rattle of machine-guns. Such, for example, is the 'profound today' celebrated in 1917 by Blaise Cendrars in phrases that tend to reduce to juxtapositions between words, boiled down to elementary sensory tempos: 'Phenomenal today. Sonde. Antenna. . . . Whirlwind. You are living. Eccentric. In complete solitude. In anonymous communion . . . Rhythm speaks. Chemism. You are.' Or again: 'We learn. We drink. Intoxication. Reality has no meaning any more. No significance. Everything is rhythm, speech life . . . Revolution. The dawn of the world. Today.'[5] This 'today' of histories abolished in favour of the micro-movements of a matter that is 'rhythm, speech and life' is one which, four years later, will be consecrated by the young art of cinema, in the equally paratactic sentences by which Blaise Cendrars's young friend, the chemist and filmmaker Jean Epstein, will devote himself to expressing the new sensory power of the shots of the seventh art.[6]

The new common term of measurement, thus contrasted

with the old one, is rhythm, the vital element of each material unbound atom which causes the image to pass into the word, the word into the brush-stroke, the brush-stroke into the vibration of light or motion. The point can be put differently: the law of 'profound today', the law of the great parataxis, is that there is no longer any measurement, anything in common. It is the common factor of dis-measure or chaos that now gives art its power.

But this measureless common factor of chaos or the great parataxis is only separated by an almost indiscernible boundary from two territories where it risks getting lost. On the one side, there is the great schizophrenic explosion, where the sentence sinks into the scream and meaning into the rhythm of bodily states. On the other, there is the great community identified with the juxtaposition of commodities and their doubles, or with the hackneyed character of empty words, or with the intoxication of manipulated intensities, of bodies marching in time. Schizophrenia or consensus. On the one hand, the great explosion, the 'frightful laugh of the idiot' named by Rimbaud, but practised or feared by the whole era that runs from Baudelaire, via Nietzsche, Maupassant, Van Gogh, Andrei Biely or Virginia Woolf, to Artaud. On the other, consent to the great equality of market and language or the great manipulation of bodies drunk on community. The measurement of aesthetic art then had to construct itself as a contradictory one, nourished by the great chaotic power of unbound elements, but able, by virtue of that very fact, to separate this chaos – or 'idiocy' – from the art of the furies of the great explosion or the torpor of the great consent.

I propose to call this term of measurement the sentence-image. By this I understand something different from the combination of a verbal sequence and a visual form. The

power of the sentence-image can be expressed in sentences from a novel, but also in forms of theatrical representation or cinematic montage or the relationship between the said and unsaid in a photograph. The sentence is not the sayable and the image is not the visible. By sentence-image I intend the combination of two functions that are to be defined aesthetically – that is, by the way in which they undo the representative relationship between text and image. The text's part in the representative schema was the conceptual linking of actions, while the image's was the supplement of presence that imparted flesh and substance to it. The sentence-image overturns this logic. The sentence-function is still that of linking. But the sentence now links in as much as it is what gives flesh. And this flesh or substance is, paradoxically, that of the great passivity of things without any rationale. For its part, the image has become the active, disruptive power of the leap – that of the change of regime between two sensory orders. The sentence-image is the union of these two functions. It is the unit that divides the chaotic force of the great parataxis into phrasal power of continuity and imaging power of rupture. As sentence, it accommodates paratactic power by repelling the schizophrenic explosion. As image, with its disruptive force it repels the big sleep of indifferent triteness or the great communal intoxication of bodies. The sentence-image reins in the power of the great parataxis and stands in the way of its vanishing into schizophrenia or consensus.

This could put us in mind of those nets stretched over chaos by which Deleuze and Guattari define the power of philosophy or of art. But since we are talking about cinematic histories here, I shall instead illustrate the power of the sentence-image by a famous sequence from a comic film. At the beginning of *A Night in Casablanca*, a policeman looks with a suspicious air at

the strange behaviour of Harpo, who is motionless with his hand against a wall. He asks him to move on. With a shake of the head, Harpo indicates that he cannot. The policeman then observes ironically that perhaps Harpo wants him to think that he is holding up the wall. With a nod, Harpo indicates that that is indeed the case. Furious that the mute should make fun of him in this way, the policeman drags Harpo away from his post. And sure enough, the wall collapses with a great crash. This gag of the dumb man propping up the wall is an utterly apt parable for making us feel the power of the sentence-image, which separates the *everything hangs together* of art from the *everything merges* of explosive madness or consensual idiocy. And I would happily compare it with Godard's oxymoronic formula, 'O sweet miracle of our blind eyes'. I shall do so with only one mediation – that of the writer who was most assiduous about separating the idiocy of art from that of the world, the writer who had to speak his sentences out loud to himself, because otherwise he saw 'only fire' in them. If Flaubert 'does not see' in his sentences, it is because he writes in the age of clairvoyance and the age of clairvoyance is precisely one in which a certain 'sight' has vanished, where *saying* and *seeing* have entered into a communal space without distance and without connection. As a result, one sees nothing: one does not see what is said by what one sees, or what is offered up to be seen by what one says. It is therefore necessary to listen, to trust the ear. It is the ear which, by identifying a repetition or an assonance, will make it known that the sentence is *false* – that is, that it does not possess the sound of the true, the breath of chaos undergone and mastered.[7] A correct sentence is the one that causes the power of chaos to subside by separating it from schizophrenic explosion and consensual stupor.

The power of the correct sentence-image is therefore that of a paratactic syntax. Expanding the notion beyond its narrow cinematic meaning, such syntax might also be called *montage*. The nineteenth-century writers who discovered behind stories the naked power of swirling dust, oppressive mugginess, streams of commodities, or forms of intensity in madness also invented montage as a measure of that which is measureless or as the disciplining of chaos. The canonical example is the agricultural show scene in *Madame Bovary*, where the power of the sentence-image rises up between the empty talk of the professional seducer and the official orator, at once extracted from the surrounding torpor where both are equal and sub-tracted from this torpor. But for the issue that concerns me, I consider the montage presented in *Le Ventre de Paris* by the episode of the preparation of the black pudding even more significant. Let me recall the context. Florent, an 1848 repub-lican who was deported during the coup d'état of 1851 but has escaped from his Guyanese penal colony, is living under a false identity in the *charcuterie* of his half-brother Quenu. Here he attracts the curiosity of his niece, little Pauline, who by chance has heard him refer to some memories of a companion eaten by animals, and the disapproval of his sister-in-law Lisa, whose business is basking in imperial prosperity. Lisa would like him to accept a vacant position as an inspector at Les Halles under his assumed identity – a compromise refused by the upright republican. At this point there occurs one of the major events in the life of the *charcuterie* – the preparation of the black pudding, constructed by Zola in an alternating montage. Mingling with the lyrical narrative of the cooking of the blood, and the enthusiasm that grips actors and spec-tators at the promise of a good black pudding, is the narrative of 'the man eaten by animals' demanded by Pauline from her

uncle. In the third person Florent tells the terrible story of deportation, the penal colony, the sufferings experienced during the escape, and the debt of blood thus sealed between the Republic and its assassins. But as this story of poverty, famine and injustice swells up, the joyous sputtering of the black pudding, the smell of fat, and the heady warmth of the atmosphere contradict it, transforming it into an incredible story told by a ghost from another age. This story of blood spilt, and of a man dying of hunger who demands justice, is refuted by the place and the circumstances. It is immoral to die of hunger, immoral to be poor and love justice – that is the lesson Lisa draws from the story. But it is the lesson that was already dictated by the joyous sound of the black pudding. At the end of the episode, Florent, deprived of his reality and his justice, is powerless before the surrounding warmth and yields to his sister-in-law, accepting the position of inspector.

Thus, the conspiracy between 'the Fat' and fat seems to triumph completely and the very logic of the alternating montage appears to consecrate the common loss of the differences of art and the oppositions of politics in some great consent to the warm intimacy of the commodity-king. But montage is not a simple opposition between two terms, where the term that gives its tone to the whole necessarily triumphs. The consensual character of the sentence in which the tension of the alternating montage is resolved does not occur without the pathetic clash of the image that restores distance. I do not evoke the conflictual complementarity of the organic and the pathetic, conceptualized by Eisenstein, by way of simple analogy. Not for nothing did he make the twenty volumes of the Rougon-Macquart the 'twenty supporting pillars' of montage.[8] The stroke of genius of the montage created by Zola here is that it contradicts the absolute victory of the Fat, the

assimilation of the great parataxis to the great consent, with a single image. He has in fact assigned Florent's speech a privileged listener, a contradictor who visually refutes him with her well-padded prosperity and her disapproving expression. This silently eloquent contradictor is the cat Mouton. As is well-known, the cat is the fetish animal of dialecticians of the cinema, from Sergei Eisenstein to Chris Marker – the animal that converts one idiocy into another, consigning triumphant reasons to stupid superstitions or the enigma of a smile. Here the cat that underscores the consensus simultaneously undoes it. Converting Lisa's rationale into its sheer laziness, through condensation and contiguity it also transforms Lisa herself into a sacred cow – a mocking representation of Juno without volition or care in which Schiller encapsulated the free appearance, the aesthetic appearance that suspends the order of the world based on an ordered relationship between ends and means and active and passive. The cat, with Lisa, condemned Florent to consent to the lyricism of the triumphant commodity. But the same cat transforms itself and transforms Lisa into mythological divinities of derision who consign this triumphant order to its idiotic contingency.

Despite the conventional oppositions between the dead text and the living image, this power of the sentence-image also animates Godard's *Histoire(s) du cinéma*, particularly our episode. Indeed, it could be that this seemingly displaced acceptance speech plays a comparable role to Zola's cat, but also to the mute propping up of the wall that separates artistic parataxis from the headlong collapse of materials, *everything hangs together* from *everything merges*. Doubtless Godard is not confronted with the complacent reign of the Fat. For, since Zola, that reign has gone on a diet of aestheticized commodities and sophisticated advertising. Godard's

problem is precisely this: his practice of montage was formed in the Pop era, at a time when the blurring of boundaries between high and low, the serious and the mocking, and the practice of jumping from one subject to the other seemed to counter-pose their critical power to the reign of commodities. Since then, however, commodities have teamed up with the age of mockery and subject-hopping. Linking anything with anything whatsoever, which yesterday passed for subversive, is today increasingly homogeneous with the reign of journalistic *anything contains everything* and the subject-hopping of advertising. We therefore need an enigmatic cat or burlesque mute to come and put some disorder back into montage. Perhaps this is what our episode does, in a tone far removed, however, from comedy. In any event, one thing is certain – something that is obviously imperceptible to the viewer of *Histoire(s)*, who knows nothing of the young girl with a candle apart from her nocturnal silhouette. This young woman has at least two things in common with Harpo. Firstly, she too, metaphorically at least, is propping up a house that is collapsing. Secondly, she too is mute.

THE GOVERNESS, THE JEWISH CHILD AND THE PROFESSOR

It is time to say a little more about the film from which this shot comes. *The Spiral Staircase* tells the story of a murderer who attacks women suffering from various handicaps. The heroine, who has become dumb following a head injury, is a clearly appointed victim for the killer, all the more so (we soon understand) in that he inhabits the same house where she has the job of governess, responsible for the care of a sick old lady and caught up in an atmosphere of hatred created by the

rivalry between two half-brothers. Having spent a night without any other means of protection than the telephone number of the doctor who loves her – not the most effective recourse for someone who cannot speak, obviously – she would have suffered her fate of destined victim had the murderer not, at the decisive moment, been killed by his mother-in-law – a new trauma as a result of which she regains her powers of speech.

How does this relate to the small child from the ghetto and the professor's inaugural lecture? Apparently as follows: the murderer is not the mere victim of irresistible drives. He is a methodical man of science whose design is to do away, for their own good and everyone else's, with beings whom nature or chance has rendered infirm, and thus incapable of a completely normal life. No doubt the plot is derived from a 1933 English novel whose author would seem not to have had any particular political motive. But the film came out in 1946, which makes it reasonable to suppose that it was made in 1945. And the director was Robert Siodmak, one of the collaborators on the legendary *Menschen am Sonntag* – a 1928 film/diagnosis of a Germany ready to give itself to Hitler – and one of the filmmakers and cameramen who fled Nazism and transposed the plastic and sometimes political shades of German Expressionism into American film noir.

Everything therefore seems to be explained: the extract is there, superimposed on the image of the ghetto's surrender, because in it a filmmaker who fled Nazi Germany speaks to us, through a transparent fictional analogy, of the Nazi programme for exterminating 'sub-humans'. This American film of 1946 echoes the *Germany, Year Zero* which an Italian director, Rossellini, shortly thereafter devoted to a different transposition of the same programme – little Edmund's murder of his bedridden father. In its fashion it attests to the way in

which cinema spoke of the extermination through exemplary fables – Murnau's *Faust*, Renoir's *La Règle du jeu*, Chaplin's *The Great Dictator*. From here it is easy to complete the puzzle, to confer meaning on each of the elements that are fitted together in the episode. The merry public that is seated in front of Nosferatu is taken from the closing shots of King Vidor's *The Crowd*. Of little importance here is the fictional situation in this film from the last days of silent movies: the final reconciliation in a music-hall of a couple on the verge of breaking up. Godard's montage is clearly symbolic. It shows us the captivation of the crowd in darkened movie theatres by the Hollywood industry, which feeds it with a warm imaginary by burning a reality that will soon demand payment in real blood and real tears. The letters that appear on the screen (*l'ennemi public, le public*) say this in their own way. *Public Enemy* is the title of a film by Wellman, a story about a gangster played by James Cagney and slightly postdating *The Crowd*. But in *Histoire(s)* it is also the title given by Godard to *The Crowd*'s producer, Irvin Thalberg – the embodiment of the power of Hollywood that vampirized cinema crowds, but also liquidated the artists/prophets of cinema à la Murnau.

The episode therefore creates a strict parallel between two captivations: the captivation of German crowds by Nazi ideology and of film crowds by Hollywood. Falling within this parallel are the intermediate elements: a man/bird shot taken from Franju's *Judex*; a close-up on the eyes of Antonioni, the paralyzed, aphasic filmmaker, all of whose power has withdrawn into his gaze; the profile of Fassbinder, the exemplary filmmaker of Germany after the catastrophe, haunted by ghosts that are represented here by the quasi-subliminal apparitions of riders taken from Fritz Lang's *Siegfried's Death*.[9] The text that accompanies these fleeting

apparitions is taken from Jules Laforgue's *Simple agonie* – that is, not only from a poet who died at the age of 26, but also from a French writer nurtured in exemplary fashion by German culture in general and by Schopenhauerian nihilism in particular.

Everything is therefore explained, except that the logic thus reconstructed is strictly indecipherable exclusively from the silhouette of Dorothy McGuire, an actress as little known to viewers of *Histoire(s)* as the film itself. Accordingly, it is not the allegorical quality of the plot that must connect the shot of the young woman and the photograph of the ghetto child for viewers. It is the power of the sentence-image in itself – that is, the mysterious bond between two enigmatic relations. The first is the material relationship between the candle held by the fictional mute and the all too real Jewish child that it seems to illuminate. Such is in fact the paradox. It is not the extermination that is to clarify the story presented by Siodmak, but quite the reverse: it is the black and white of cinema that is to project on to the image of the ghetto the power of history that it derives from great German cameramen like Karl Freund, who (Godard tells us) invented in advance the lighting effects of Nuremberg, and which they themselves derived from Goya, Callot or Rembrandt and his 'terrible black and white'. And the same is true of the second mysterious relationship contained in the sentence-image: the relationship between Foucault's words and the shot and photograph that they are supposed to link. In accordance with the same paradox, it is not the obvious link provided by the film's plot that is to unite the heterogeneous elements, but the non-link of these words. The interesting thing, in fact, is not that a German director in 1945 should stress the analogies between the screenplay entrusted to him and the contemporary reality of war and

extermination, but the power of the sentence-image as such –
the ability of the staircase shot to come directly into contact
with the photograph of the ghetto and the words of the
professor. A power of contact, not of translation or explana-
tion; an ability to exhibit a community constructed by the
'fraternity of metaphors'. It is not a question of showing that
cinema speaks of its time, but of establishing that cinema
makes a world, that it should have made a world. The history
of cinema is the history of a power of making history. Its time,
Godard tells us, is one when sentence-images had the power,
dismissing *stories*, to write *history*, by connecting directly up
with their 'outside. This power of connecting is not that of the
homogeneous – not that of using a horror story to speak to us
of Nazism and the extermination. It is that of the heteroge-
neous, of the immediate clash between three solitudes: the
solitude of the shot, that of the photograph, and that of the
words which speak of something else entirely in a quite
different context. It is the clash of heterogeneous elements
that provides a common measure.

How should we conceive this clash and its effect? To under-
stand it, it is not enough to invoke the virtues of fragmentation
and interval that unravel the logic of the action. Fragmenta-
tion, interval, cutting, collage, montage – all these notions
readily taken as criteria of artistic modernity can assume
highly diverse (even opposed) meanings. I leave to one side
instances where fragmentation, whether cinematic or novelis-
tic, is simply a way of tying the representative knot even more
tightly. But even omitting this, there remain two major ways of
understanding how the heterogeneous creates a common mea-
sure: the dialectical way and the symbolic way.

DIALECTICAL MONTAGE, SYMBOLIC MONTAGE

I take these two terms in a conceptual sense that goes beyond the boundaries of some particular school or doctrine. The dialectical way invests chaotic power in the creation of little machineries of the heterogeneous. By fragmenting continuums and distancing terms that call for each other, or, conversely, by assimilating heterogeneous elements and combining incompatible things, it creates clashes. And it makes the clashes thus developed small measuring tools, conducive to revealing a disruptive power of community, which itself establishes another term of measurement. This machinery can be the encounter of the sewing machine and the umbrella on a dissecting table, some canes and Rhine mermaids in an antiquated shop window of the Passage de l'Opéra,[10] or quite different equivalents of these accessories in Surrealist poetry, painting or cinema. The encounter therein of incompatible elements highlights the power of a different community imposing a different measure; it establishes the absolute reality of desires and dreams. But it can also be activist photomontage à la John Heartfield, which exposes capitalist gold in Adolf Hitler's gullet – i.e. the reality of economic domination behind the lyricism of national revolution – or, forty years later, that of Martha Rosler, who 'brings back home' the Vietnam War by mixing her images with those of adverts for American domestic bliss. Even closer to us, it can be the images of the homeless projected by Krzystof Wodiczko on official American monuments, or the paintings that Hans Haacke accompanies with little notices indicating how much they have cost each of their successive buyers. In all these cases, what is involved is revealing one world behind another: the far-off conflict behind

home comforts; the homeless expelled by urban renovation behind the new buildings and old emblems of the polity; the gold of exploitation behind the rhetoric of community or the sublimity of art; the community of capital behind all the separations of spheres and the class war behind all communities. It involves organizing a clash, presenting the strangeness of the familiar, in order to reveal a different order of measurement that is only uncovered by the violence of a conflict. The power of the sentence-image that couples heterogeneous elements is then that of the distance and the collision which reveals the secret of a world – that is, the other world whose writ runs behind its anodyne or glorious appearances.

The symbolist way also relates heterogeneous elements and constructs little machines through a montage of unrelated elements. But it assembles them in accordance with the opposite logic. Between elements that are foreign to one another it works to establish a familiarity, an occasional analogy, attesting to a more fundamental relationship of co-belonging, a shared world where heterogeneous elements are caught up in the same essential fabric, and are therefore always open to being assembled in accordance with the fraternity of a new metaphor. If the dialectical way aims, through the clash of different elements, at the secret of a heterogeneous order, the symbolist way assembles elements in the form of mystery. Mystery does not mean enigma or mysticism. Mystery is an aesthetic category, developed by Mallarmé and explicitly adopted by Godard. The mystery is a little theatrical machine that manufactures analogy, which makes it possible to recognize the poet's thought in the feet of a dancer, the fold of a stole, the opening of a fan, the sparkle of a chandelier, or the unexpected movement of a standing bear. It is also what enables the stage designer Adolphe Appia to translate the

thought of the musician/poet Wagner not into painted scenery that resembles what the opera is about, but into the abstract plastic forms of pieces of working scenery or the beam of light that sculpts space; or the static dancer Loïe Fuller to transform herself, solely by the artifice of her veils and spotlights, into the luminous figure of a flower or butterfly. The machine of mystery is a machine for making something common, not to contrast worlds, but to present, in the most unexpected ways, a co-belonging. And it is this common element that provides the term of measurement of the incommensurables.

The power of the sentence-image is thus extended between these two poles, dialectical and symbolic; between the clash that effects a division of systems of measurement and the analogy which gives shape to the great community; between the image that separates and the sentence which strives for continuous phrasing. Continuous phrasing is the 'dark fold that restrains the infinite', the supple line that can proceed from any heterogeneous element to any heterogeneous element; the power of the uncoupled, of what has never been begun, never been coupled, and which can conquer everything in its ageless rhythm. It is the sentence of the novelist who, even if we cannot 'see' anything in it, vouches by his ear that we are in the true, that the sentence-image is right. The 'right' image, Godard recalls citing Reverdy, is one that establishes the correct relationship between two remote things grasped in their maximum distance. But the rightness of the image is definitely not seen. The sentence must make its music heard. What can be grasped as right is the sentence – that is, what is given as always preceded by another sentence, preceded by its own power: the power of phrased chaos, of Flaubert's mixing of atoms, of Mallarmé's arabesque, of the original 'whispering' the idea for which Godard borrowed from Hermann Broch.

And it is indeed this power of the non-begun, this power of the uncoupled redeeming and consecrating the artifice of any link, which Foucault's sentences express here.

What is the relationship between the homage to the absent one in the inaugural lecture, the shadows of a shot from a film noir, and the image of the condemned ones in the ghetto? One might answer: the relationship between the pure contrast of black and white and the pure continuity of the uncoupled sentence. Here Foucault's sentences say what Godard's sentences – the ones he borrows from Broch or Baudelaire, Elie Faure, Heidegger or Denis de Rougemont – do, throughout *Histoire(s) du cinéma*: they bring into play the coupling power of the uncoupled, the power of what always precedes oneself. The paragraph from Foucault says nothing else *here*. It says the same thing as the sentence from Althusser twenty years earlier. It invokes the same power of continuous phrasing, the power of what is given as the continuation of a sentence that is always-already begun. Even more than the peroration cited by Godard, this power is expressed by the exordium to which it refers:

> I would have preferred to be enveloped in words, borne away beyond all possible beginnings. At the moment of speaking, I would like to have perceived a nameless voice, long preceding me, leaving me merely to enmesh myself in it, taking up its cadence, and to lodge myself, when no one was looking, in its interstices as if it had paused an instant, in suspense, to beckon me.[11]

This power of linking seemingly cannot be generated by the simple relationship between two visible elements. The visible does not succeed in phrasing itself continuously, in providing the measure of the 'without common measurement', the

measure of mystery. Cinema, says Godard, is not an art, not a technique. It is a mystery. For my part, I would say that it is not such in essence, but that it is such as phrased here by Godard. There is no art that spontaneously pertains to one or the other form of combining heterogeneous elements. It must be added that these two forms themselves never stop intermingling their logics. They work on the same elements, in accordance with procedures that verge on the indiscernible. Godard's montage doubtless offers the best example of the extreme proximity of contrasting logics. It shows how the same forms of junction of heterogeneous elements can abruptly switch from the dialectical pole to the symbolist pole. Interminably to connect, as he does, a shot from one film with the title or dialogue of another, a sentence from a novel, a detail from a painting, the chorus of a song, a news photograph, or an advertising message, is always to do two things at once: to organize a clash and construct a continuum. The space of these clashes and that of the continuum can even bear the same name: History. History can indeed be two contradictory things: the discontinuous line of revealing clashes or the continuum of co-presence. The linkage of heterogeneous elements constructs and, at the same time, reflects a meaning of history that is displaced between these two poles.

Godard's career illustrates this displacement in exemplary fashion. He has in fact never stopped practising the collage of heterogeneous elements. But for a very long time it was spontaneously perceived as dialectical. This is because the clash of heterogeneous elements possessed a sort of dialectical automaticity in itself. It referred to a vision of history as a locus of conflict. This is what is summarized in a phrase from *Made in the USA*: 'I have the impression', says the hero, 'of living in a Walt Disney film played by Humphrey Bogart – so

in a political film.' An exemplary deduction: the absence of any relationship between the associated elements sufficed to vouch for the political character of the association. Any linkage of incompatible elements could pass for a critical 'appropriation' of the dominant logic and any abrupt switch of subject for a Situationist *dérive*. *Pierrot le fou* provides the best example of this. The tone is set from the outset by the sight of Belmondo in his bath with a cigarette, reading Elie Faure's *Histoire de l'art* to a little girl. We then see Ferdinand-Pierrot's wife recite the advertising jingle about the benefits she would derive from the Scandale girdle and hear him waxing ironic about the 'civilization of the backside'. This mockery is continued by the evening at the parents-in-law where the guests, against a monochrome background, repeat expressions from advertising. Thereafter the hero's flight with the baby-sitter – the rediscovered sweetheart – can begin. The political message conveyed by this opening is far from obvious. But the 'advertising' sequence, because it refers to an established grammar of the 'political' reading of signs, sufficed to ensure a dialectical view of the film and to classify the elopement under the heading of critical *dérive*. To tell a cock-and-bull detective story, to show two young people on the run having their breakfast with a fox or a parrot, entered unproblematically into a critical tradition of denunciation of alienated everyday life.

This also meant that the strange linkage between a text of 'high culture' and the laid-back lifestyle of a young man from the New Wave era was enough to make us indifferent to the content of the Elie Faure text read by Ferdinand. Now, in connection with painting, this text on Velasquez was already saying the same thing that Godard would have Foucault's text say about language twenty years later. Velasquez, Elie Faure essentially argues, has placed on canvas 'representing' the

sovereigns and princesses of a decadent dynasty something quite different: the power of space, imponderable dust, the impalpable caress of the breeze, the gradual expansion of shadow and light, the colourful palpitations of the atmosphere.[12] In Velasquez, painting is the phrasing of space; and the historiography of art practised by Elie Faure echoes it as the phrasing of history.

In the era of Pop and Situationist provocations, Godard at once invoked and obscured this phrasing of history imaginarily extracted from the pictorial phrasing of space. By contrast, it triumphs in the dream of the original great whisper that haunts *Histoire(s) du cinéma*. The methods of 'appropriation' which, twenty years earlier, produced, even blankly, dialectical conflict, now assume the opposite function. They ensure the logic of mystery, the reign of continuous phrasing. Thus, in the first part of *Histoire(s)* Elie Faure's chapter on Rembrandt becomes a eulogy of cinema. Thus, Foucault, the philosopher who explained to us how words and things had separated off, is summoned to vouch positively for the illusion that his text evoked and dispelled, to make us hear the original murmur where the sayable and the visible are still joined. The procedures for linking heterogeneous elements that ensured dialectical conflict now produce the exact opposite: the homogeneous great layer of mystery, where all of yesterday's conflicts become expressions of intense co-presence.

With yesterday's provocations we can now contrast today's counter-provocations. I have commented elsewhere on the episode where Godard shows us – with the help of Giotto's Mary Magadalen, transformed by him into an angel of the Resurrection – that Elizabeth Taylor's 'place in the sun' in the film of that name was made possible because the film's director, George Stevens, had a few years earlier filmed the

survivors and the dead of Ravensbrück, thereby redeeming cinema from its absence from the scenes of the extermination.[13] Now, if it had been made at the time of *Pierrot le fou*, the link between the images of Ravensbrück and the idyll of *A Place in the Sun* could only have been read in one way: a dialectical reading denouncing American happiness in the name of the camp victims. This dialectical logic is what still inspired Martha Rosler's photomontages, linking American happiness to Vietnamese horror, in the 1970s. Yet however anti-American the Godard of *Histoire(s)*, his reading is the exact opposite: Elizabeth Taylor is not guilty of selfish happiness, indifferent to the horrors of the world. She has positively merited this happiness because George Stevens has positively filmed the camps and thus performed the task of the cinematic sentence-image: constructing not the 'designerless dress of reality', but the seamless fabric of co-presence – the fabric that at once authorizes and erases all the seams; constructing the world of 'images' as a world of general co-belonging and inter-expression.

Dérive and appropriation are thus reversed, absorbed by the continuity of the phrasing. The symbolist sentence-image has swallowed the dialectical sentence-image. The 'without common measurement' now leads to the great fraternity or community of metaphors. This move is not peculiar to a filmmaker known for his especially melancholic temperament. In its way it translates a shift in the sentence-image, to which today's works attest even when they present themselves in the form of legitimations taken from the dialectical lexicon. This is the case, for example, with the exhibition *Moving Pictures* that was recently staged at the Guggenheim Museum in New York. The rhetoric of the exhibition sought to enrol today's artworks in a critical tradition from the 1960s and '70s, where the methods

of the filmmaker and the visual artist, the photographer and
the video director, would be united in an identical radicalism
challenging the stereotypes of the dominant discourse and
view. Yet the exhibited works did something different. Thus,
Vanessa Beecroft's video, in which the camera revolves around
upright naked female bodies in the space of the same museum,
is, despite formal similarities, no longer concerned to denounce
the link between artistic stereotypes and female stereotypes.
Indeed, the strangeness of these displaced bodies seems instead
to suspend any such interpretation, to allow these presences
their mystery, which fades to join that of photographs them-
selves intent on recreating the pictorial formulas of magical
realism: Rineke Dijkstra's portraits of adolescents whose sex,
age and social identity are ambiguous; Gregory Crewdson's
photographs of ordinary suburbs caught in uncertainty be-
tween the drab colour of the everyday and the murky colour of
the drama with which cinema has so often played; and so on.
Between videos, photos and video installations, we see the
indicated querying of perceptual stereotypes shift towards a
quite different interest in the uncertain boundaries between the
familiar and the strange, the real and the symbolic. At the
Guggenheim, this shift was spectacularly underscored by the
simultaneous presence, between the same walls, of Bill Viola's
video installation called *Going Forth by Day*: five simultaneous
video projections covering the walls of a dark rectangular
room, where visitors stand on a central carpet. Around the
entry way there is a great primeval fire from which a human
hand and face vaguely emerge; while on the facing wall, there is
a deluge of water that is about to submerge a multitude of
picturesque urban characters, whose movements have been
related and features detailed by the camera at length. The left
wall is completely taken up by the décor of an airy forest where

characters whose feet hardly touch the ground slowly, and interminably, walk backwards and forwards. Life is a transition, we have understood, and we can now turn towards the fourth wall, which is divided between two projection spaces. The one on the left is divided in two: in a small closet à la Giotto an old man is dying watched over by his children; whereas on a terrace à la Hopper a character peers into the Nordic sea where, while the old man dies and the light is extinguished in the room, a boat is slowly loaded and sets out. On the right, a group of exhausted rescue workers of a flooded village rest, while on the sea's edge a woman awaits morning and rebirth.

Bill Viola does not attempt to hide a certain nostalgia for the great painting and the fresco series of yesteryear and says that what he wanted to create here was an equivalent of Giotto's frescos in the chapel of Arena in Padua. But this series instead puts us in mind of the great frescos of the ages and seasons of human existence that people were fond of in the Symbolist and Expressionist era, at the time of Puvis de Chavannes, Klimt, Edvard Munch, or Erich Heckel. It will doubtless be said that the temptation to Symbolism is inherent in video art. And, in fact, the immateriality of the electronic image has quite naturally rekindled the enthusiasm of the Symbolist era for immaterial states of matter – an enthusiasm prompted at the time by the progress of electricity and the success of theories about the dissipation of matter in energy. In the period of Jean Epstein and Riccioto Canudo, this enthusiasm had sustained enthusiasm for the young art of cinematography. And it is also quite natural that video should offer Godard its new capacities for making images appear, vanish, and intermingle; and for forming the pure kingdom of their co-belonging and the potentiality of

their inter-expression *ad infinitum*.

But the technique that makes this poetics possible does not create it. And the same shift from dialectical conflict to symbolist community is characteristic of works and installations that employ traditional materials and means of expression. The exhibition *Sans commune mesure* presents, for example, the work of Ken Lum in three rooms. This artist still identifies with the North American critical tradition of the Pop age. Into various advertising signs and billboards he has inserted subversive statements advocating the power of the people or the liberation of an imprisoned Indian activist. But the hyper-realist materiality of the sign devours the difference of the texts; without distinction, it puts the plaques and their inscriptions in the imaginary museum of objects witnessing to the everyday life of middle America. As for the mirrors that line the following room, they no longer have anything in common with those which, twenty years earlier, Pistoletto, sometimes engraving a familiar silhouette on them, substituted for the expected paintings, thereby demanding of visitors obliged to see their reflections in them what they had come to look for. With the small family photos that embellish them, Lum's mirrors, by contrast, seem to expect us, to summon us to recognize ourselves in the image of the great human family.

I previously commented on the contemporary contrast between the icons of *voici* and the displays of *voilà*, stressing that the same objects or assemblages could indifferently pass from one exhibitory logic to the other. In the light of Godard's complementarity of icon and montage, these two poetics of the image seem to be two forms of the same basic trend. Today, the photographic sequences, the video monitors or projections, the installations of familiar or strange objects that fill the spaces of our museums and galleries seek less to create the

sense of a gap between two orders – between everyday appearances and the laws of domination – than to increase a new sensitivity to the signs and traces that testify to a common history and a common world. It is sometimes the case that forms of art explicitly declare themselves to this effect, that they invoke a 'loss of community' or undoing of the 'social bond', assigning the assemblages and performances of art the task of recreating social bonds or a sense of community. The reduction of the great parataxis to the ordinary state of things then takes the sentence-image towards its degree zero: the little sentence that creates a bond or beckons towards some bond. But outside of these professed forms, and under the cover of legitimations still taken from the critical *doxa*, contemporary forms of art are increasingly devoted to the unanimist inventory of traces of community or a new symbolist representation of the powers of the verbal and the visible or of the archetypal gestures and great cycles of human existence.

The paradox of *Histoire(s) du cinéma* thus does not reside where it first of all seems to be situated: in the conjunction of an anti-textual poetics of the icon and a poetics of montage that makes these icons the endlessly combinable and exchangeable elements of a discourse. The poetics of *Histoire(s)* simply radicalizes the aesthetic power of the sentence-image as a combination of opposites. The paradox lies elsewhere: this monument was in the nature of a farewell, a funeral chant to the glory of an art and a world of art that have vanished, on the verge of the latest catastrophe. Yet *Histoire(s)* may well have signalled something quite different: not the onset of some twilight of the human, but the neo-symbolist and neo-humanist tendency of contemporary art.

3

Painting in the Text

'Too many words': the diagnosis is repeated whenever the crisis of art, or its subservience to aesthetic discourse, is denounced. Too many words about painting; too many words that comment on its practice and devour it; that clothe and transfigure the 'anything goes' it has become or replace it in books, catalogues and official reports – to the point of spreading to the very surfaces where it is exhibited and where, in its stead, we find written the pure affirmation of its concept, the self-denunciation of its imposture, or the registration of its end.

I do not intend to respond to these claims on their own ground. Instead, I would like to ponder the configuration of this ground and the way in which the particulars of the problem are set out in it. From there I would like to turn the game upside down and move from polemical denunciation of the words that encumber painting to a theoretical understanding of the articulation between words and visual forms that defines a regime of art.

At first sight, things seem clear: on the one hand, there are practices; on the other hand, their interpretations; on the one hand, there is the pictorial phenomenon and on the other the torrent of discourse about it which philosophers, writers or artists themselves have poured out, since Hegel and Schelling made painting a form of manifestation of a concept of art that

was itself identified with a form of unfolding of the absolute. But this simple opposition starts to blur when one poses the question: what precisely does this 'pictorial phenomenon' set against the supplement of discourse consist in?

The commonest reply takes the form of a seemingly irrefutable tautology. The peculiarity of the pictorial phenomenon is that it only uses means specific to painting: coloured pigments and flat, two-dimensional space. The simplicity of this answer accounts for its success, from Maurice Denis to Clement Greenberg. Yet it leaves many ambiguities unresolved. We can all agree that the peculiarity of an activity consists in using the means specific to it. But a means is specific to an activity in as much as it is apt to achieve the purpose that is specific to the activity. The particular purpose of a mason's labour is not defined by the material he works on and the tools he uses. What, then, is the specific purpose that is realized by putting coloured pigments on a flat surface? The response to this question is in fact an intensification of the tautology: the specific purpose of painting is *solely* to put coloured pigments on a flat surface, rather than to people it with representative figures, referred to external entities situated in a three-dimensional space. 'The Impressionists', Clement Greenberg thus says, 'abjured underpainting and glazing, to leave the eye under no doubt as to the fact that the colours used were made of real paint that came from pots or tubes.'[1] Let us accept that such was indeed the intention of the Impressionists (which is doubtful). There are nevertheless many ways of demonstrating that you are using tubes of real paint: you can mention the fact on the canvas or alongside the canvas; you can stick these tubes to it, or replace the canvas by a small window containing them, or arrange big pots of acrylic paint in the middle of an empty room, or organize a happening where the painter takes

a dip in the paint. All these methods, which are empirically attested to, indicate that the artist is using a 'real' material, but they do so at the expense of the flat surface where the demonstration of painting 'itself' was to be staged. They do it while uncoupling the two terms whose substantial unity it was supposed to demonstrate: the material – pigmental or other – and the two-dimensional surface. They therewith pose the question: why must painters 'leave the eye under no doubt' that they are using real paint from tubes? Why must the theoretician of 'pure' painting show us that the Impressionist use of pure colours has this as its purpose?

The reason is that this definition of the pictorial phenomenon is in fact an articulation of two contradictory operations. It wants to guarantee the identity of the pictorial material and the painting-form. The art of painting is the specific realization of nothing but the possibilities contained in the very materiality of coloured matter and its support. But this realization must take the form of a self-demonstration. The same surface must perform a dual task: it must only be itself and it must be the demonstration of the fact that it is only itself. The concept of *medium* guarantees this secret identity of opposites. 'To use nothing but the *medium* specific to an art' means two things. On the one hand, it means carrying out a purely technical operation: the gesture of squeezing some pictorial material on to an appropriate surface. It remains to be known what the 'peculiarity' of this appropriation is and what makes it permissible, as a result, to refer to this operation as pictorial art. For that the word 'medium' must refer to something quite different from a material and a support. It must designate the ideal space of their appropriation. The notion must therefore be discreetly split in two. On the one hand, the *medium* is the set of material means available for a technical activity.

'Conquering' the medium then signifies: confining oneself to the use of these material means. On the other hand, the stress is placed on the very relationship between end and means. Conquering the medium then signifies the converse: appropriating the means to make it an end in itself, denying the relationship of means to end that is the very essence of technique. The essence of painting – simply casting coloured matter on a flat surface – is to suspend the appropriation of means to an end that is the essence of technique.

The idea of the specificity of pictorial technique is consistent only at the price of its assimilation to something quite different: the idea of the autonomy of art, of the exception of art from technical rationality. If it is necessary to *show* that you are using tubes of colour – and not simply to use them – it is in order to demonstrate two things: firstly, that this use of tubes of colour is nothing but the use of tubes of colour, only technique; and secondly, that it is something quite different from the use of tubes of colour, that it is art – i.e. anti-technique.

In fact, contrary to the claim of the thesis, it always has to be *shown* that the material displayed on some surface is art. There is no art without eyes that see it as art. Contrary to the healthy doctrine which would have it that a concept is the generalization of the properties common to a set of practices or objects, it is strictly impossible to present a concept of art which defines the properties common to painting, music, dance, cinema, or sculpture. The concept of art is not the presentation of a property shared by a set of practices – not even that of one of those 'family resemblances' which Wittgenstein's followers call upon in the last resort. It is the concept of a disjunction – and of a historically determinate unstable disjunction – between *the arts*, understood in the sense of practices, ways of making.

Art as we call it has existed for barely two centuries. It was not born thanks to the discovery of the principle shared by the different arts – in the absence of which *tours de force* superior to those of Clement Greenberg would be required to make its emergence coincide with the conquest by each art of its specific 'medium'. It was born in a long process of rupture with the system of beaux arts – that is, with a different regime of disjunction in the arts.

That different regime was encapsulated in the concept of *mimesis*. Those who regard *mimesis* as simply the imperative of resemblance can construct a straightforward idea of artistic 'modernity' as the emancipation of the peculiarity of art from the constraint of imitation: the reign of coloured beaches in the place of naked women and war horses. This is to miss the main thing: *mimesis* is not resemblance but a certain regime of resemblance. *Mimesis* is not an external constraint that weighed on the arts and imprisoned them in resemblance. It is the fold in the order of ways of making and social occupations that rendered them visible and thinkable, the disjunction that made them exist as such. This disjunction is twofold. On the one hand, it separated the 'beaux arts' from the other arts – simple 'techniques' – in accordance with their specific purpose: imitation. But it also shielded the imitations of the arts from the religious, ethical or social criteria that normally governed legitimate uses of resemblance. *Mimesis* is not resemblance understood as the relationship between a copy and a model. It is a way of making resemblances function within a set of relations between ways of making, modes of speech, forms of visibility, and protocols of intelligibility.

That is why Diderot can criticize Greuze on the paradoxical grounds that he has darkened the skin of his Septimus Severus and represented Caracalla as an absolute rogue.[2] Septimus

Severus was the first Roman emperor of African origin and his son Caracalla was indeed a mischievous Frank. The painting by Greuze under criticism represents the latter at the point when he is convicted of attempted parricide. But the resemblances of representation are not reproductions of reality. An emperor is an emperor before he is an African; and the son of an emperor is a prince before being a rascal. To darken the face of the one, and accuse the other of baseness, is to transform the noble genre of the history painting into the common genre of painting that is appropriately called genre painting. The correspondence between the order of the painting and the order of history is the affinity between two orders of grandeur. It inscribes the practice of art, and the images it offers for our inspection, in a general order of relations between making, seeing and saying.

There is such a thing as art in general by virtue of a regime of identification – of disjunction – that gives visibility and signification to practices of arranging words, displaying colours, modelling the volume or evolution of bodies; which decides, for example, what a painting is, what one does by painting, and what one sees on a painted wall or canvas. But such a decision always involves the establishment of a regime of equivalence between a practice and what it is not. To know whether music and dance were arts, Batteux asked whether they were imitations; whether, like poetry, they recounted stories, organized actions. The *ut pictura poesis/ut poesis pictura* did not simply define the subordination of one art – painting – to another – poetry. It defined a relationship between the orders of making, seeing, and saying whereby these arts – and possibly others – were arts. The issue of flatness in painting, imitation of the third dimension, and rejection of that imitation is not in any way a question of

discriminating between the peculiarity of pictorial art and the peculiarity of sculptural art. Perspective was not adopted in order to demonstrate the painter's ability to imitate the depth of space and the contours of bodies. Painting would not have become one of the 'beaux arts' merely by offering proof of this technical capacity. A painter's virtuosity has never sufficed to open the doors of artistic visibility for him. If perspective was linear and theatrical before becoming aerial and sculptural, it is because painting first of all had to demonstrate its capacity for poetry – its ability to tell stories, to represent speaking, acting bodies. The bond between painting and the third dimension is a bond between painting and the poetic power of words and fables. What can undo this bond, assign painting a privileged relationship not only to the use of flat surface but also to the affirmation of flatness, is a different type of relationship between what painting does and what words make visible on its surface.

For painting to be destined for flatness, it must be made to be seen as flat. For it to be seen as flat, the links that connect its images in the hierarchies of representation have to be loosened. It is not necessary that painting should no longer 'resemble'. It is sufficient for its resemblances to be uncoupled from the system of relations that subordinate the resemblance of images to the ordering of actions, the visibility of painting to the quasi-visibility of the words of poems, and the poem itself to a hierarchy of subjects and actions. The destruction of the mimetic order does not mean that since the nineteenth century the arts have done 'anything they like'; or that they have freely embarked on the conquest of the possibilities of their particular medium. A medium is not a 'proper' means or material. It is a surface of conversion: a surface of equivalence between the different arts' ways of making; a conceptual space of

articulation between these ways of making and forms of visibility and intelligibility determining the way in which they can be viewed and conceived. The destruction of the representative regime does not define some finally discovered essence of art as such in itself. It defines an aesthetic regime in the arts that is a different articulation between practices, forms of visibility and modes of intelligibility.

What inducted painting into this regime was not the rejection of representation, not a revolution in the practice of painters. It was primarily a different way of seeing the painting of the past. The destruction of the representative regime in painting started at the beginning of the nineteenth century, with the revocation of the hierarchy of genres, with the rehabilitation of 'genre painting' – the representation of ordinary people engaged in ordinary activities, which used to be contrasted with the dignity of history painting as comedy to tragedy. It therefore began with the revocation of the subordination of pictorial forms to poetic hierarchies, of a certain bond between the art of words and that of forms. But this liberation was not the separation of painting from words, but a different way of conjoining them. The power of words is no longer the model that pictorial representation must take as its norm. It is the power that hollows out the representative surface to make the manifestation of pictorial expressiveness appear on it. This means that the latter is only present on the surface to the extent that a gaze penetrates it; that words amend the surface by causing another subject to appear under the representative subject.

This is what Hegel paradigmatically does in his endeavour to rehabilitate Dutch painting – pioneer of the labour of redescription which throughout the Romantic era, when faced with the works of Gerard Dou, Teniers or Adrian Brouwer,

like those of Rubens and Rembrandt, developed the new visibility of a 'flat' painting, an 'autonomous' painting. The true subject of these despised paintings, explains Hegel, is not what we see at first. It is not tavern scenes, episodes of bourgeois existence, or domestic accessories. It is the autonomization of these elements, the severing of the 'threads of representation' that attached them to the reproduction of a repetitive style of existence. It is the replacement of these objects by the light of their appearance. What occurs on the canvas is now an epiphany of the visible, an autonomy of pictorial presence. But this autonomy is not the installation of painting in the solitude of its own peculiar technique. It is itself the expression of a different autonomy – the autonomy the Dutch people succeeded in wresting in their triple struggle against a hostile nature, the Spanish monarchy, and Papal authority.[3]

For painting to attain flatness, the surface of the painting has to be divided in two; a second subject has to be shown under the first. Greenberg counter-poses to the naivety of Kandinsky's anti-representative programme the idea that the important thing is not the abandonment of figuration, but the conquest of surface. But this conquest is itself a work of de-figuration: a labour that renders the same painting visible in a different way, that converts figures of representation into tropes of expression. What Deleuze calls the logic of sensation is much more a theatre of de-figuration, where figures are wrenched from the space of representation and reconfigured in a different space. Proust calls this de-figuration denomination, when characterizing the art of pure sensation in Elstir: 'if God the Father had created things by naming them, it was by taking away their names or giving them other names that Elstir created them anew.'[4]

The surface claimed as the specific medium of pure painting is in fact a different medium. It is the theatre of a de-figuration/denomination. Greenberg's formalism, which would reduce medium to material, and Kandinsky's spiritualism, which makes it a spiritual milieu, are two ways of interpreting this de-figuration. Painting is flat in as much as words change their function with respect to it. In the representative order, they served as its model or norm. As poems, as sacred or profane history, they outlined the arrangement that the composition of the painting had to translate. Thus, Jonathan Richardson recommended to painters that they first of all write the story of the painting in order to know whether it was worth painting. As critical discourse, words compared what was painted with what should have been: the same story conveyed in a more appropriate attitude and physiognomy or a story more worthy of being painted. It is often said that aesthetic criticism, the criticism which emerged in the Romantic era, no longer proceeds normatively; no longer compares the painting with what it should have been. But the opposition between the norm and its absence, or between the external norm and the internal norm, conceals the main thing: the contrast between two modes of identification. In the aesthetic age, the critical text no longer says what the painting should be or should have been. It says what it is or what the painter has done. But to say that is to arrange the relationship between the sayable and the visible, the relationship between the painting and what it is not, differently. It is to reformulate the *like* of the *ut pictura poesis*, the *like* whereby art is visible, whereby its practice is attuned to a way of seeing and falls within a way of thinking. It has not disappeared. It has changed places and functions. It works towards the de-figuration, the alteration of what is visible on its surface, and hence towards its visibility as art.

To see something as art, be it a *Deposition from the Cross* or a *White Square on White Background*, means seeing two things in it at once. Seeing two things at once is not a matter of trompe-l'oeil or special effects. It is a question of the relations between the surface of exhibition of forms and the surface of inscription of words. But this new bond between signs and forms that is called criticism, and which is born at the same time as the proclamation of the autonomy of art, does not work in the simple form of retrospective discourse adding meaning to the nakedness of forms. It works in the first instance towards the construction of a new visibility. A new form of painting is one that offers itself to eyes trained to see differently, trained to see the pictorial appear on the representative surface, under representation. The phenomenological tradition and Deleuzian philosophy readily assign art the task of creating presence under representation. But presence is not the nakedness of the pictorial thing as opposed to the significations of representation. Presence and representation are two regimes of the plaiting of words and forms. The regime of visibility of the 'immediacies' of presence is still configured through the mediation of words.

This labour is what I would like to show at work in two texts of nineteenth-century criticism − texts that reconfigure the visibility of what painting does. The first, by placing a representative painting of the past in the new regime of presence, constitutes the new mode of visibility of the pictorial, appropriate for the contemporary painting that it nevertheless disdains. The second, in celebrating a new form of painting, projects it into an 'abstract' future of painting that does not as yet exist.

I take my first example from the monograph on Chardin published by the Goncourt brothers in 1864:

Against one of those muffled, mixed backgrounds that he knows so well how to rub in, and amid which a coolness, as in a grotto, mingles vaguely with the cast shadows of a sideboard, on one of those coloured tables like moss and topped with dull marble, which so often bear his signature, Chardin pours out dessert plates: here is the shaggy velvet of the peach, the amber transparency of the white grape, the sugary rime of the plum, the moist crimson of strawberries, the hardy berry of the muscatel and its smoke-blue mist, the wrinkles and tubercules of an orange skin, the embroidered guipure of melons, the copperas of old apples, the knots in a crust of bread, the smooth rind of the chestnut and the wood of the hazel nut . . . In one corner there is apparently nothing more than a mud-coloured texture, the marks of a dry brush, then, suddenly a walnut appears curling up in its shell, showing its sinews, revealing itself with all the details of its form and colour.[5]

The whole of this text is governed by one aim: to transform figurative particulars into events of pictorial matter, which themselves convey metamorphic states of matter. The operation might be conveniently summarized starting from the last lines: the curling up of the walnut, the appearance of the figure in the mud-coloured texture and the marks of a dry brush. The 'matterism' of the Goncourts' description prefigures a major form of visibility of pictorial 'autonomy': the working of the material, of the coloured paste asserting its sway over the space of the painting. It configures in Chardin's painting a whole future of Impressionism and Abstract Expressionism or action-painting. It also prefigures in it a whole future of descriptions and theorizations: conceptualization of the formless à la Bataille, of original mimesis à la Merleau-Ponty, or of the Deleuzian diagram – the operation of a hand that cancels one visibility in order to produce another: a 'tactile' visibility, the visibility of the gesture of the painter substituted for that of

its result. The domestic still life does not possess any privilege in this regard. The description of Rubens's great religious paintings observes the same principle: 'Never has a paintbrush so furiously rolled and unrolled lumps of flesh, tied and untied clusters of bodies . . .' .

This transformation of the visible into the tactile and of the figurative into the figural is only possible through the highly specific labour of the writer's words. It first of all consists in the deictic mode of the utterance, a mode of presence indicated through the operation of a literalization which shows us Chardin 'pouring out' the plates – that is, transforming the representation of the table into a gesture of projection which renders the acts of spreading colour and laying the table equivalent. Next it consists in the whirlwind of adjectives and metaphors that succeed in articulating two contradictory operations. They transform the qualities of the fruits represented into substantial states of matter. The amber, the rime, the mist, the wood, or the moss of some living matter take the place of the grape, the plums, the hazel nuts, and the table of the represented still life. At the same time, however, they systematically blur the identities of objects and the boundaries between realms. Thus, the guipure of the melon, the wrinkles of the orange, or the copperas of the apple endow the plants with the features of human faces or works, whereas moss, coolness, and film transform solid elements into liquid ones. Both operations conduce to the same result. Linguistic tropes change the status of the pictorial elements. They transform representations of fruits into tropes of matter.

This transformation is much more than an aesthete's re-reading. The Goncourts simultaneously register and configure a new visibility of the pictorial phenomenon, an aesthetic-type visibility where a relationship of coalescence between the

density of the pictorial matter and the materiality of the painter's gesture is imposed in place of the representative privilege of the form that organized and cancelled matter. They elaborate the new regime of visibility that makes a new pictorial practice possible. To do this, they do not need to appreciate the new painting. It has often been remarked that, with reference to Chardin, Rubens or Watteau, the Goncourts elaborate the visibility of Impressionist canvases. But no law of necessary similarity obliges them to accommodate on the canvases of innovators the viewing machine thus constructed. For them pictorial novelty is already realized, already present in the present woven by the interweaving of their linguistic tropes with Chardin's brush-strokes and figures. When innovators want to make the physical play of light and the hachure of colour directly equivalent, they short-circuit the labour of metaphor. One might say, in Deleuzian terms, that they make diagrams which remain diagrams. But if Deleuze helps us understand why Edmond de Goncourt cannot see the paintings he has rendered visible, the converse is also perhaps true: Goncourt helps us understand what Deleuze, in order to preserve the idea of painting as a labour of sensation on sensation, tries not to see – the pictorial diagram only makes visible if its labour is rendered equivalent to that of metaphor, if words construct such equivalence.

To construct that equivalence is to create solidarity between a practice and a form of visibility. But this solidarity is not a necessary contemporaneity. On the contrary, it is asserted through an interplay of temporal distances that remove pictorial presence from any epiphany of the present. The Goncourts see Impressionism already realized in Chardin. They see it because they have produced its visibility through a labour of de-figuration. De-figuration sees novelty

in the past. But it constitutes the discursive space that renders
novelty visible, which constructs a gaze for it in the very
discrepancy of temporalities. Accordingly, the discrepancy is
as much prospective as retrospective. It not only sees novelty
in the past. It can also see as yet unrealized possibilities of
painting in the present work.

This is what is revealed by another critical text – the one
Albert Aurier devoted in 1890 to Gaugin's *Vision du sermon*
(also known as *La Lutte de Jacob avec l'ange*). This text is a
manifesto for a new kind of painting, a painting that no longer
represents reality but translates ideas into symbols. Yet this
manifesto does not proceed by a polemical argument. It too
proceeds by a de-figurative description, which uses certain
devices from the mystery story. It plays on the discrepancy
between what is seen and what is not seen in order to establish
a new status of the visible in painting:

> Far off, very far off, on a mythical hill whose soil is a rutilant
> vermilion in appearance, we have the biblical struggle between
> Jacob and the Angel.
>
> While these two legendary giants, transformed into pygmies by
> the distance, fight their fearsome fight, some women are watching.
> Concerned and naïve, they doubtless understand little of what is
> going on over there, on that fabulous crimson hill. They are
> peasants. And from the size of their headdresses spread like
> seagulls' wings, the typical mixed colours of their scarves, the
> form of their dresses or blouses, we can tell that they come from
> Brittany. They have the respectful attitudes and wide-eyed expres-
> sions of simple creatures listening to rather supernatural, extra-
> ordinary tales from a mouth that is above reproach and revered.
> So silently attentive are they, so contemplative, bowed and devout
> is their bearing, that one would say they were in a church. One
> would say they were in a church and that a vague scent of incense

and prayer was wafting about the white wings of their headdresses and that the respected voice of an old priest was hovering about their heads . . . Yes, no doubt, in a church, in some poor church in some poor, small Breton village . . . But if so, where are the mouldy green pillars? Where are the milky-white walls with the tiny monolithographic Stations of the Cross? Where is the wooden pulpit? Where is the old parish priest who is preaching? . . . And why over there, far off, very far off, is that fabulous hill, whose soil seems to be of a rutilant vermilion, looming up? . . .

Ah! It is because the mouldy green pillars, and the milky-white walls, and the little chromolithographic Stations of the Cross, and the wooden pulpit, and the old parish priest who is preaching have long since been wiped out, no longer exist for the eyes and souls of the good Breton peasants! . . . What wonderfully touching accents, what luminous hypotyposis, strangely appropriate to the crude ears of his oafish audience, has this mumbling village Bossuet encountered? All surrounding materialities have vanished in smoke, have disappeared. The one calling out has himself faded away and it is now his voice, his poor old pitiful, mumbling Voice that has become visible, imperiously visible. And it is his Voice that is contemplated with naïve, rapt attention by these peasants with white headdresses; and it is his Voice this rustically fantastic vision, looming up over there, very far off; his Voice this legendary hill whose soil is vermilion-coloured, this childish dreamland, where the two biblical giants, transformed into pygmies by the distance, are fighting their hard, fearsome fight![6]

This description is constructed through a mechanism of mystery-making and substitutions, placing three paintings in one. There is a first painting: some peasant women in a meadow who are watching the fighters in the distance. But this appearance condemns itself as incoherent and calls for a second painting: to be dressed thus and have these attitudes, the peasants should not be in a meadow; they should be in a

church. Therewith Aurier evokes what a painting of this church would normally be: a genre painting with miserable décor and grotesque characters. But this second painting, which would impart a certain context to the contemplative bodies of the peasants – the context of a realist, regional painting of social customs – is not there. The painting we do see precisely constitutes its refutation. In and through this refutation, we must therefore see a third painting – that is, see Gaugin's painting from a new angle. The spectacle it presents us with has no real location. It is purely ideal. The peasants do not witness any realistic scene of sermon and struggle. They – and we – see the Voice of the preacher: the words of the Word that pass via this voice. These words tell of the legendary fight of Jacob with the Angel, of terrestrial materiality with celestial ideality.

Thus, the description is a substitution. It replaces one scene of speech by another. It does away with the story with which the representative painting was in harmony; and it does away with the scene of speech to which the spatial depth was adjusted. It replaces them by a different 'living word': the words of Scripture. And the painting thus appears as the site of a conversion. What we see, Aurier tells us, is not some scene of peasant life, but an ideal pure surface where certain ideas are expressed by certain signs, making figurative forms the letters of an alphabet peculiar to painting. Description then makes way for a neo-Platonic discourse that shows us in Gaugin's painting the novelty of an abstract art, where visible forms are merely signs of the invisible idea: an art breaking with the realist tradition and its latest novelty – Impressionism. Removing the genre painting that should have been there, Aurier replaces it by a correspondence between the 'conceptual' purity of the abstract painting and the beatific vision of the

'naïve' listener. For the representative relationship he substitutes the expressive relationship between the abstract ideality of form and the expression of a content of collective consciousness. This spiritualism of pure form is the counterpart of the 'matterism' of the pictorial gesture exemplified by the Goncourts. Unquestionably, the contrast runs throughout the nineteenth century: Raphael and an Italian purity of form against Rembrandt/Rubens and a Dutch epiphany of physical matter. Yet it merely repeats the old controversy over drawing and colour. The very controversy is caught up in the elaboration of a new visibility of painting. 'Ideaism' and 'matterism' contribute equally to forming the visibility of an 'abstract' painting – not necessarily painting without representation, but painting that oscillates between pure realization of the metamorphoses of matter and translation of the pure force of 'internal necessity' into lines and colours.

It might readily be objected to Aurier's demonstration that what we see on the canvas is not signs but easily identifiable figurative forms. The peasants' faces and poses are schematized. But this very schematism assimilates them not so much to the Platonic Idea as to the advertising images which still embellish Pont-Aven biscuits today. The scene of the struggle is at an uncertain distance, but the relation of vision to the semi-circle of peasants remains ordered in accordance with a consistent representative logic. And the cloisonné spaces of the painting remain connected by a visual logic that is consistent with the narrative logic. In order to assert a radical break between the old 'materialist' painting and a new conceptual painting, Aurier must go significantly beyond what we see on the canvas. Through thought he must liberate the coloured spots that are still coordinated by a narrative logic and transform schematized images into abstract schemas. In the space

of visibility that his text constructs for it, Gaugin's painting is already a painting of the sort Kandinsky would paint and justify: a surface where lines and colours have become expressive signs obeying the single constraint of 'internal necessity'.

The objection simply boils down to confirming this: the 'internal necessity' of the abstract canvas is itself only constructed in the device whereby words work the painted surface so as to construct a different plane of intelligibility for it. This comes down to saying that the flat surface of the painting is something quite different from the self-evidence of the law of a medium that has finally been conquered. It is a surface of dissociation and de-figuration. Aurier's text establishes in advance a peculiarity of painting, an 'abstract' painting. But it also revokes in advance any identification of this 'peculiarity' with the law of a surface or material. The dismissal of representative logic is not the straightforward assertion of the physical materiality of the painting, refusing any subservience to discourse. It is a new mode of the correspondence, the 'like' that linked painting to poetry, visual figures to the order of discourse. Words no longer prescribe, as story or doctrine, what images should be. They make themselves images so as to shift the figures of the painting, to construct this surface of conversion, this surface of forms-signs which is the real medium of painting – a medium that is not identified with the propriety of any support or any material. The form-signs that Aurier's text makes visible on the surface of Gaugin's painting are open to being refigured in various ways – in the pure flatness of the abstract 'language of forms', but also in all the combinations of the visual and the linguistic which will be presented by Cubist or Dadaist collages, the appropriations of Pop Art, the décollages of the new realists, or the plain writing

of Conceptual Art. The ideal plane of the painting is a theatre of de-figuration, a space of conversion where the relationship between words and visual forms anticipates visual de-figurations still to come.

I have spoken of theatre. This is not a 'mere metaphor'. The arrangement in a circle of peasant women with their backs to the viewer, and absorbed by a distant spectacle, obviously puts us in mind of the ingenious analyses of Michael Fried, inventing a pictorial modernity conceived as anti-theatre, as an inversion of the motion of actors towards the audience. The obvious paradox is that this anti-theatre itself comes directly from the theatre – very precisely from the naturalist theory of the 'fourth wall' invented by a contemporary of Gaugin and Aurier: the theory of a dramatic action that would pretend to be invisible, to be viewed by no audience, to be nothing but life in its pure similarity to itself. But what need would life in its pure similarity, life 'not looked at', not made into a spectacle, have of speaking? The 'formalist' dream of a kind of painting that turns its back on the spectator in order to close in on itself, in order to adhere to the surface that is peculiar to it, could well be nothing but the other side of the same identitarian dream. A pure painting, clearly separate from 'spectacle', would be required. But theatre is not primarily 'spectacle', is not the 'interactive' site calling upon the audience to finish the work denounced by Fried. Theatre is first and foremost the space of visibility of speech, the space of problematic translations of what is said into what is seen. Accordingly, it is quite true, it is the site of expression of the impurity of art, the 'medium' which clearly shows that there is no peculiarity of art or of any art; that forms do not proceed without the words that install them in visibility. The 'theatrical' arrangement of Gaugin's peasant women establishes the 'flatness' of the painting only at

the cost of making this surface an interface that transfers the images into the text and the text into the images. The surface is not wordless, is not without 'interpretations' that pictorialize it. In a way, this was already the lesson of Hegel and the meaning of the 'end of art'. When the surface is no longer split in two, when it is nothing more than a site for the projection of pigments, Hegel taught, there is no longer any art. Today, this thesis is commonly interpreted in a nihilistic sense. In advance, Hegel supposedly condemned art for art's sake to the fate of 'anything goes' or showed that now, rather than works of art, there are 'only interpretations'. The thesis seems to me to require a different reading. It is indeed true that Hegel personally turned the page on art, put art on his page – that of the book which tells the past the mode of its presence. But that does not mean that he turned the page for us in advance. Instead, he alerted us to this: the present of art is always in the past and in the future. Its presence is always in two places at once. He tells us in sum that art is alive as long as it is outside itself, as long as it does something different from itself, as long as it moves on a stage of visibility which is always a stage of *defiguration*. What he discourages in advance is not art, but the dream of its purity. It is the modernity that claims to vouchsafe each art its autonomy and painting its peculiar surface. Here indeed is something to fuel resentment against philosophers who 'talk too much'.

4

The Surface of Design

If I speak here of design, it is not as an art historian or a philosopher of technique. I am neither. What interests me is the way in which, by drawing lines, arranging words or distributing surfaces, one also designs divisions of communal space. It is the way in which, by assembling words or forms, people define not merely various forms of art, but certain configurations of what can be seen and what can be thought, certain forms of inhabiting the material world. These configurations, which are at once symbolic and material, cross the boundaries between arts, genres and epochs. They cut across the categories of an autonomous history of technique, art or politics. This is the standpoint from which I shall broach the question: how do the practice and idea of design, as they develop at the beginning of the twentieth century, redefine the place of artistic activities in the set of practices that configure the shared material world – the practices of creators of commodities, of those who arrange them in shop windows or put their images in catalogues; the practices of constructors of buildings or posters, who construct 'street furniture', but also of politicians who propose new forms of community around certain exemplary institutions, practices or facilities – for example, *electricity and soviets*? Such is the perspective that will guide my inquiry. As to my method, it will be that of children's

guessing games, where the question is how two things resemble or differ from one another.

In the event, the question might be formulated as follows: what resemblance is there between Stéphane Mallarmé, a French poet writing *Un coup de dés jamais n'abolira le hasard* in 1897, and Peter Behrens, German architect, engineer and designer who, ten years later, was in charge of designing the products, adverts and even buildings of the electricity company AEG (*Allgemeine Elektrizitäts Gesellschaft*)? On the face of it, this is a stupid question. Mallarmé is known as the author of poems that became increasingly rare, short and quintessential as his poetic art developed. The latter is generally epitomized by a contrast between two states of language: a crude state that serves for communication, description, instruction, and hence for a use of speech analogous to the circulation of commodities and currency; and an essential state that 'transposes a fact of nature into its virtual vibratory disappearance' so as to reveal the 'pure notion'.

What relationship is there between a poet thus defined and Peter Behrens, an engineer in the service of a major brand producing bulbs, kettles or heaters? Unlike the poet, Behrens is involved in the mass production of utilitarian equipment. And he is also the supporter of a unified, functionalist vision. He wants everything submitted to the same principle of unity, from the construction of workshops to the brand's logogram and advertising. He wants to reduce the objects produced to a certain number of 'typical' forms. What he calls 'imparting style' to his firm's output assumes the application of a single principle to objects and to the icons that offer them to the public: stripping the objects and their images of any decorative prettiness, of anything that answers to the routines of buyers or sellers and their rather silly dreams of luxury and sensual

pleasure. Behrens wants to reduce objects and icons to essential forms, geometrical motifs, streamlined curves. According to this principle, he wants the design of objects to approximate as closely as possible to their function, and the design of the icons that represent them to approximate as closely as possible to the information they are supposed to provide about those objects.

So what is there in common between the prince of Symbolist aesthetes and the engineer of large-scale utilitarian production? Two main things. First of all, a common denominator that serves to conceptualize what both of them are doing. Peter Behrens counter-poses his streamlined, functional forms to the overly ornate forms or Gothic typographies in favour in Germany at the time. He calls these streamlined forms 'types'. The term seems far removed from the Symbolist poem. At first sight it evokes the standardization of products, as if the engineer-artist was anticipating the assembly line. The cult of the pure, functional *line* in effect combines three meanings of the word. It resumes the old classical privilege of drawing over colour, while diverting it to other purposes. In fact, it places the 'classical' cult of the line in the service of a different *line* – the product line distributed by the unit of the AEG brand for which he works. It thus effects a displacement of the great classical canons. The principle of unity in diversity becomes that of the brand image which is carried by the whole set of that brand's products. Finally, this *line*, which is at once the graphic design and the product line put at the disposal of the public, ultimately destines both to a third *line* – i.e. the assembly line.

Yet Peter Behrens has something in common with Stéphane Mallarmé – namely, precisely the word but also the idea of a 'type'. For Mallarmé too proposes 'types'. The object of his

poetics is not the assemblage of precious words and rare pearls, but the layout of a design. For him every poem is a layout that abstracts a basic scheme from the spectacles of nature or of the accessories of life, thereby transforming them into essential forms. It is no longer spectacles that are seen or stories that are told, but world-events, world-schemes. In Mallarmé every poem thus assumes a typical analogical form: the fan that is flicked open and flicked closed, the foam that is fringed, the hair that is displayed, the smoke that clears. It is always schemes of appearance and disappearance, presence and absence, unfolding and refolding. Mallarmé calls these schemes, these abridged or streamlined forms, 'types'. And he will search for their principle in a graphic poetry: a poetry identical with the composition of motion in space, whose model is provided for him by choreography, a certain idea of ballet. For Mallarmé the latter is a form of theatre where what is produced is not psychological characters, but graphic types. Together with story and character disappears the operation of resemblance, in which spectators assemble to enjoy the spectacle of their own embellished image on the stage. To it Mallarmé opposes dance conceived as a writing of types, a writing of gestures, which is more essential than any writing traced by a pen.

The definition of it provided by Mallarmé enables us to identify the relationship between the aims of the poet and the engineer:

> . . . the judgement or axiom to affirm as regards ballet – namely, that the dancer is not a woman who dances, for the following juxtaposed reasons: she is not a woman but a metaphor epitomizing one of the elementary aspects of our form – sword, bowl, flower, etc. – and she does not dance, suggesting by means of the

marvel of foreshortening or momentum, through a corporeal writing, what it would require paragraphs of dialogic as well as descriptive prose to express in written form. A poem freed of any scribal apparatus.

This poem freed of any scribal apparatus can be compared with those industrial products and symbols of industrial products that are abstract and separated from the consumption of resemblance and prettiness – the 'aesthetic' consumption which complements the ordinary course of circulation of commodities, words and currencies. The poet, like the engineer, wants to oppose to it a language of streamlined form, a graphic language.

If these types must be substituted for the decorum of objects or stories, it is because the forms of the poem, like those of the object, are also forms of life. This is the second feature that brings together the poet of the virtually nothing and the artist engineer manufacturing *en masse*. For both of them, types outline the image of a certain physical community. Behrens's work as a designer applies the principles of *Werkbund*, which dictate restoring 'style' in the singular, as opposed to the proliferation of styles plural bound up with capitalist, commodity anarchy.[1] The *Werkbund* aspires to a correspondence between form and content. It wants the form of the object to correspond to its body and to the function it is to perform. It wants a society's forms of existence to convey the internal principle that makes it exist. This correspondence between the form of objects and their function, and between their icons and their nature, is at the heart of the idea of 'type'. Types are the formative principles of a new communal life, where the material forms of existence are informed by a shared spiritual principle. In the type, industrial form and artistic form are

conjoined. The form of objects is then a formative principle of life forms.

Mallarmé's types involve similar concerns. The text on Villiers de l'Isle Adam where Mallarmé speaks of the 'meaningless gesture of writing' is often quoted. It is used to illustrate the theme of the nocturnal poet of silence and impossibility. But the phrase should be read in context. What does this 'meaningless gesture of writing' consist in? Mallarmé replies: 'recreating everything with reminiscences so as to prove that one is indeed where one should be'. 'Recreating everything with reminiscences' is the principle of the quintessential poem, but it is also that of graphics and the schematism of advertising. Poetic labour for Mallarmé is a labour of simplification. Like engineers, he dreams of an alphabet of essential forms, taken from the ordinary forms of nature and the social world. These reminiscences, these creations of abridged forms answer to the need to construct an abode where man is at home. This concern resonates with the unity of form and content of an existence aimed at by the concept of style in Behrens. Mallarmé's world is a world of artefacts that represent such types, such essential forms. This world of artefacts must consecrate the human abode, prove that one is where one should be. For, at the time when Mallarmé was writing, such certainty was in doubt. Together with the old pomp of religion and monarchy, the traditional forms of symbolization of a shared grandeur were vanishing. And the problem was to replace them so as to give the community its 'seal'.

A famous text by Mallarmé speaks of replacing 'the shadow of yesteryear' – religion and especially Christianity – by 'some splendour': a human grandeur that would be constituted by anything whatsoever, by assembling objects and elements taken at random in order to confer on them an essential form,

the form of a type. Mallarmé's types are thus a substitute for
the sacraments of religion, the difference being that with them
one does not consume the flesh and blood of any redeemer.
Counter-posed to the eucharistic sacrifice is the pure gesture of
the elevation, the consecration of human artifice and human
imagining as such.

Between Mallarmé and Behrens, between the pure poet and
the functionalist engineer, there therefore exists this singular
link: the same idea of streamlined forms and the same function
attributed to these forms – to define a new texture of com-
munal existence. No doubt these shared concerns are ex-
pressed in very different ways. The designer engineer
intends to revert to a state prior to the difference between
art and production, utility and culture; to return to the identity
of a primordial form. He seeks this alphabet of types in the
geometrical line and the productive act, in the primacy of
production over consumption and exchange. For his part,
Mallarmé doubles the natural world and the social world with
a universe of specific artefacts that can be the fireworks of 14
July, the vanishing lines of the poem, or the knick-knacks with
which the private life is imbued. And doubtless the designer
engineer would situate Mallarmé's project in Symbolist icono-
graphy – that of the *Jugenstil* which he regards as the mere
decoration of the commodity world, but whose concern for
styling life by styling its furnishings he nevertheless shares.

An intermediate figure might help us to think through this
proximity in distance, or distance in proximity, between the
poet Mallarmé and the engineer Behrens: a figure on the
border between choreographic poem and advertising image.
From among the choreographic spectacles in which Mallarmé
seeks a new model for the poem, he selects that of Loïe Fuller.
Loïe Fuller is an almost completely forgotten character today.

At the turn of the nineteenth century, however, she played an emblematic role in the development of a new paradigm of art. Her dancing is of a quite particular kind. Loïe Fuller does not trace figures with her feet. She remains static. She dances with her dress, which she unfolds and refolds, making herself a fountain, a flame or a butterfly. The play of spotlights sets this folding and unfolding ablaze, transforms it into fireworks and makes Loïe Fuller a luminous statue, combining dance, sculpture and the art of light into a hyper-mediatic type of work. She is thus an exemplary graphic emblem of the age of electricity. But her icon is not restricted to that. In her day Loïe Fuller was endlessly reproduced in every form. She appears to us as a butterfly-woman, exemplifying Secession style, in Koloman Moser's pen drawings. She is made into an anthropomorphic vase or lamp in art-deco creations. She also becomes an advertising icon; and it is as such that we find her on the posters of the Odol brand according to a simple principle: the letters 'Odol' are projected onto the folds of her dress in the manner of the light projections on the stage.

Obviously, I have not selected this example at random. This figure enables us to think through the proximity and the distance between the poet's types and the engineer's. Like AEG, Odol, a brand of German mouthwash, was a pioneering firm in research into advertising graphics, through the development of its own brand image. It thereby offers us an interesting parallel with the principles of design à la Behrens. On the one hand, its design approximates to them: the bottle is of a simple, functional design, that remained untouched for decades. But on the other hand, it contrasts with them: on the posters, the bottle is often associated with romantic landscapes. One poster puts a Böcklin landscape on the little bottle. On another, the letters 'Odol' outline a Greek am-

phitheatre in a landscape evoking the ruins at Delphi. Contrasting with the functionalist unity of message and form are these extrinsic forms of sensitization that associate utilitarian gargling with dreamlike scenes. But perhaps there is a third level where the antagonists meet. For forms that are 'extrinsic' in one sense are not so extrinsic in another. Odol's graphic designer in fact utilizes the quasi-geometrical character of the brand's letters, treating them as visual elements. The latter take the form of three-dimensional objects that wander in space, are distributed in the Greek landscape, and outline the ruins of the amphitheatre. This transformation of the graphic signifier into visual volume anticipates certain uses of painting; and Magritte did indeed draw inspiration from the Odol amphitheatre for his *Art de la conversation*, where an architecture of ruins is likewise constructed with letters.

This equivalence of the graphic and the visual creates the link between the poet's types and the engineer's. It visualizes the idea which haunts both of them – that of a common physical surface where signs, forms and acts become equal. On Odol posters, alphabetical signs are playfully transformed into three-dimensional objects subject to a perspectivist principle of illusion. But this three-dimensionalization of signs precisely yields a reversal of pictorial illusionism: the world of forms and the world of objects make do with the same flat surface – the surface of alphabetical signs. But this surface of equivalence between words and forms proposes something altogether different from a formal game: an equivalence between the forms of art and the forms of objects of everyday living. This ideal equivalence is rendered literal in the letters, which are also forms. It unifies art, object and image at a level beyond the things that oppose the ornaments of the Symbolist poem or graphic design, governed by the idea of

'mystery', to the geometrical and functional rigour of the engineer's design.

Here we perhaps have the solution to a frequently posed problem. Commentators who study the birth of design and its relationship with industry and advertising ponder the ambivalence of its forms and the dual personality of its inventors. Thus, someone like Behrens first of all appears in the functional role of artistic advisor to the electricity company; and his art consists in designing objects that sell well and constructing catalogues and posters that stimulate sales. In addition, he becomes a pioneer of the standardization and rationalization of work. At the same time, however, he places everything he does under the sign of a spiritual mission: providing society, through a rational form of labour process, manufactured products and design, with its spiritual unity. The simplicity of the product, its style corresponding to its function, is much more than a 'brand image': it is the mark of a spiritual unity that is to unify the community. Behrens often refers to the nineteenth-century English writers and theoreticians associated with the Arts and Crafts movement. The latter wished to reconcile art and industry by means of the decorative arts and the restoration of craft industry. To explain his work as an engineer-rationalizer, Behrens invokes the major figures in this movement, Ruskin and William Morris. Yet in the middle of the nineteenth century did not these two elaborate a neo-Gothic reverie, counter-posing to the world of industry, the ugliness of its products and the slavery of its workers a backward-looking vision of artisans combined in guilds, engaged in fine craftsmanship and making, with the joy and devotion of artists, objects that were to become both the artistic décor of the modest life and the means of its education?

How, it is then asked, was this backward-looking, neo-

Gothic, spiritualist ideology able to nurture in William Morris an idea of socialism and a socialist commitment that was not some mere fad of an aesthete, but the practice of an activist involved on the ground in social struggles? How, passing from England to Germany, was this idea able to become the modernist-functionalist ideology of the *Werkbund* and *Bauhaus* and, in the case of Behrens, the ideology of functional engineering, in the service of the specific ends of an industrial combine?

An initial response consists in saying that the one ideology is a convenient cover for the other. The reveries of artisans reconciled with the fine craftsmanship and collective faith of times past is a spiritualist mystification concealing a quite different reality: submission to the principles of capitalist rationality. When Peter Behrens becomes artistic advisor to AEG and uses Ruskin's principles to design the firm's logos and adverts, the neo-Gothic idyll reveals its prosaic truth: the production line.

That is one way of explaining things. But it is not the most interesting. Rather than contrasting reality and illusion, mystification and its truth, it is better to look for what the 'neo-Gothic reverie' and the modernist/productivist principle have in common. It consists in the idea of the reconfiguration of a shared material world by working on its basic elements, on the form of the objects of everyday life. This shared idea can be translated into a return to craft industry and socialism, a Symbolist aesthetic, and industrial functionalism. Neo-Gothicism and functionalism, Symbolism and industrialism, have the same enemy. They all denounce the relationship that obtains between the soulless production of the world of commodities and the ersatz soul imparted to objects by their pseudo-artistic prettification.

It must be remembered that the 'neo-Gothics' of Arts and Crafts were the first to state certain principles which were subsequently adopted by the *Bauhaus*: an armchair is primarily beautiful if it answers to its function and, consequently, if its forms are streamlined and purified, doing away with the tapestries containing foliage, little children and animals that constituted the 'aesthetic' décor of English petit-bourgeois existence. Something of this passes into the shared idea of the symbol: the symbol in the strict – even advertising – sense *à la* Behrens and the symbol *à la* Mallarmé or Ruskin.

A symbol is primarily an abbreviating sign. It can be imbued with spirituality and given a soul. Alternatively, it can be reduced to its function of simplifying form. But both have a common conceptual core that authorizes all such moves. I referred to it in connection with the text by Albert Aurier that makes Gaugin's *La Vision du sermon* a manifesto for symbolism in painting. The mystical peasant women iconized in abbreviated forms, which Aurier makes into neo-Platonic symbols, are also the Breton women in headdresses and collars who featured as advertising icons on the boxes of Pont-Aven biscuits for almost a century. The same idea of the abbreviating symbol, the same idea of the type, unites the ideal form and the advertising icon.

There is thus a shared conceptual core that authorizes the shifts between the Symbolist arabesque and functional advertising symbolization. In similar fashion, poets or painters, Symbolists and industrial designers, make the symbol the abstract element shared by the thing, the form and its idea. The same idea of a descriptive composition of forms involves a multiplicity of practices and interpretations. Between 1900 and 1914, the graphic designers of Secession pass from the curves of poisonous flowers to rigorous geometrical constructs, as if

one and the same idea of the abbreviating symbol informed both practices. The same principles and the same thinkers of artistic form make it possible to theorize pictorial abstraction and functional design. Through a series of misunderstandings, these masters, like Aloïs Riegl with his theory of the organic ornament and Wilhelm Wörringer with his theory of the abstract line, became theoretical guarantors of painting's evolution into abstractionism: an art that expresses only the volition – the idea – of the artist, by means of symbols which are signs translating an internal necessity. But their texts also served as the basis for developing an abbreviated language of design, where it was a question of constructing not a visual alphabet of pure signs, but on the contrary a motivated alphabet for the forms of everyday objects.

This community of principle between sign and form, between the form of art and the form of the everyday object, given concrete expression by the graphic design of the early twentieth century, might lead us to reassess the dominant paradigms of the modernist autonomy of art and of the relationship between art forms and life forms. We know how, since Clement Greenberg, the idea of the flat surface has been associated with an idea of artistic modernity, conceived as art's conquest of its own medium, breaking with its submission to external ends and the mimetic imperative. Each art is said to begin to exploit its own means, its own medium, its own material. Thus, the paradigm of the flat surface has served to construct an ideal history of modernity: painting abandoned the illusion of the third dimension, bound up with the mimetic constraint, to constitute the two-dimensional space of the canvas as its own space. And the pictorial plane thus conceived exemplifies the modern autonomy of art.

The problem with this view is that this ideal artistic mod-

ernity never stops being sabotaged by infernal trouble-makers. Scarcely has Malevitch or Kandinsky posited the principle than the army of Dadaists and Futurists emerges, transforming the purity of the pictorial plane into its opposite: a surface for a melange of words and forms, art forms and mundane things. People readily put this perversion down to the pressure exercised by the languages of advertising and propaganda. It was to be repeated in the 1960s, when Pop Art emerged to overturn the regime of two-dimensional painting, restored by lyrical abstraction, and initiate a new, enduring confusion between art forms and the manipulation of purposeful objects and the circulation of commercial messages.

Perhaps we would escape these scenarios of diabolical perversion if we understood that the lost paradise never in fact existed. Pictorial flatness was never synonymous with the autonomy of art. The flat surface was always a surface of communication where words and images slid into one another. And the anti-mimetic revolution never signified renunciation of resemblance. *Mimesis* was the principle not of resemblance, but of a certain codification and distribution of resemblances. Thus, the pictorial third dimension had as its principle less the will to render the third dimension 'as such', than an attempt on the part of painting to be 'like poetry', to present itself as the theatre of a history and imitate the power of rhetorical and dramatic speech. The mimetic order was based on the separation of the arts *and* their connection. Painting and poetry imitated each other, while keeping their distance from one another. So the principle of the anti-mimetic aesthetic revolution is not some 'each to his own', confining each art to its own peculiar medium. On the contrary, it is a principle of 'each to everyone else's'. Poetry no longer imitates painting; painting no longer imitates poetry. This does not mean words on one

side, forms on the other. It means quite the opposite: the abolition of the principle that allocated the place and means of each, separating the art of words from that of forms, temporal arts from spatial arts. It means the constitution of a shared surface in place of separate spheres of imitation.

Surface is to be understood in two senses. In the literal sense, first of all. The community between the Symbolist poet and the industrial designer is made possible by the melanges of letters and forms effected by the Romantic renewal of typography, new techniques of engraving, or the development of poster art. But this surface of communication between the arts is as ideal as it is material. That is why the silent dancer, who unquestionably moves in the third dimension, can furnish Mallarmé with the paradigm of a graphic ideal, ensuring the exchange between the arrangement of words and the layout of forms, between the phenomenon of speaking and that of outlining a space. From it will derive, in particular, the typographical/ choreographic arrangement of *Un coup de dés*, the manifesto of a poetry that has become a spatial art.

The same thing is evident in painting. Between Maurice Denis and Kandinsky, there is no autonomous purity that has been wrested, only immediately to be lost by melanges – Simultaneist, Dadaist, Futurist – of words and forms, inspired by the frenzy of advertising or an industrial aesthetics. 'Pure' painting and 'impure' painting alike are based on the same principles. I previously alluded to the reference by promoters of design to the same authors – Riegl or Wörringer – who legitimate the abstract purity of painting. More generally, the same idea of surface grounds the painting that puts expressive signs of 'internal necessity' on the 'abstract' canvas and the painting that mixes pure forms, newspaper extracts, metro tickets or clock cog-wheels. Pure painting and 'corrupted'

painting are two configurations of an identical surface composed of shifts and melanges.

This also means that there is not an autonomous art on the one hand and a heteronomous art on the other. Here too a certain idea of modernity translates into a scenario of diabolical perversion: the autonomy wrested from the mimetic constraint was immediately corrupted by revolutionary activism, enrolling art in the service of politics. This hypothesis of a lost purity is best set aside. The shared surface on which forms of painting simultaneously become autonomous and blend with words and things is also a surface common to art and non-art. The anti-mimetic, modern aesthetic break is not a break with art that is a slave to resemblance. It is a break with a regime of art in which imitations were simultaneously autonomous and heteronomous: autonomous in that they constituted a sphere of verbal or visual creations not subject to the criteria of utility or truth operative elsewhere; heteronomous in so far as they imitated in their particular order – in particular, through the separation and hierarchy of genres – the social distribution of position and worth. The modern aesthetic revolution effected a break with this dual principle: it is the abolition of the parallelism that aligned artistic hierarchies with social hierarchies; the assertion that there are no noble or base subjects and that everything is a subject for art. But it is also the abolition of the principle that separated the practices of imitation from the forms and objects of ordinary existence.

Accordingly, the surface of graphic design is three things: firstly, the equal footing on which everything lends itself to art; secondly, the surface of conversion where words, forms and things exchange roles; and thirdly, the surface of equivalence where the symbolic writing of forms equally lends itself to

expressions of pure art and the schematization of instrumental art. This ambivalence does not mark some capture of the artistic by the political. 'Abbreviated forms' are, in their very principle, an aesthetic and political division of a shared world: they outline the shape of a world without hierarchy where functions slide into one another. The finest illustration of this might be the posters designed by Rodchenko for the aircraft company Dobrolet. The stylized forms of the plane and the letters of the brand are combined in homogeneous geometrical forms. But this graphic homogeneity is also a homogeneity between the forms that serve to construct Suprematist paintings and those that serve to symbolize both the élan of Dobrolet planes and the dynamism of a new society. The same artist does abstract paintings and makes instrumental posters; in both cases, he is working in identical fashion to construct new forms of life. This is also the artist who uses the same principle of homogenization by flatness for collages illustrating Mayakovsky's texts and for off-centre photographs of starts in a gymnastic display. In all these instances, the purity of art and the combination of its forms with forms of life go together. This is the visual response to the theoretical question I posed. In it the Symbolist poet and the functionalist engineer confirm the shared character of their principle on one and the same surface.

5

Are Some Things Unrepresentable?

The issue raised by my title does not call for a straightforward yes or no. Instead, it bears on this question: under what conditions might it be said that certain events cannot be represented? Under what conditions can an unrepresentable phenomenon of this kind be given a specific conceptual shape? Obviously, this line of inquiry is not neutral. It is motivated by a certain intolerance for an inflated use of the notion of the unrepresentable and a constellation of allied notions: the unpresentable, the unthinkable, the untreatable, the irredeemable. This inflated usage subsumes under a single concept all sorts of phenomena, processes and notions, ranging from Moses's ban on representation, via the Kantian sublime, the Freudian primal scene, Duchamp's *Grand verre* or Malevitch's *White Square on White Background*, to the Shoah; and it surrounds them all with the same aura of holy terror. The issue then becomes how, and under what conditions, it is possible to construct such a concept, which proposes to cover all spheres of experience univocally.

I would like to introduce this general question starting from a narrower inquiry that focuses on representation as a regime of thinking about art. What precisely is being said when it is maintained that certain entities, events or situations cannot be represented by artistic means? Two different things, it seems to me. First, that it is impossible to make the essential character

of the thing in question present. It cannot be brought before our eyes; nor can a representative commensurate with it be found. A form of material presentation that is adequate to its idea; or, conversely, a scheme of intelligibility equal to its material power – these are not to be found. This first impossibility thus posits an incapacity on the part of art.

The second, by contrast, challenges art's exercise of its power. It says that a thing cannot be represented by artistic means on account of the very nature of those means, of three characteristic properties of artistic presentation. Firstly, the latter is characterized by its surplus of presence, which betrays the singularity of the event or situation, recalcitrant as it is to any plenary material representation. Secondly, this surplus of material presence has as its correlate a status of unreality, which removes from the thing represented its weight of existence. Finally, this interplay of surplus and subtraction operates according to a specific mode of address that delivers the thing represented over to affects of pleasure, play or distance which are incompatible with the gravity of the experience it contains. Some things, it is then said, fall outside the competence of art. They cannot adapt to the surplus of presence and subtraction of existence peculiar to it, and which in Platonic terms define its character as simulacrum.

To the simulacrum Plato counter-poses the straightforward tale, one without artifice, removed from the interplay of enhanced presence and diminished existence, and likewise free of doubt as to the identity of its teller. It is this contrast between straightforward tale and mimetic artifice which today governs the prestige accorded to the word of the witness in its two forms. The first of these esteems the straightforward tale, which does not constitute art but simply conveys an individual's experience. The second, by contrast, regards 'the

witness's narrative' as a new mode of art. This involves not so much recounting the event as witnessing to a *there was* that exceeds thought, not only through its own particular surplus, but because the peculiarity of the *there was* in general is to exceed thought. Thus, in Lyotard in particular, the existence of events that exceed what can be thought calls for an art that witnesses to the unthinkable in general, to the essential discrepancy between what affects us and such of it as our thinking can master. It is then the peculiarity of a new mode of art – sublime art – to record the trace of the unthinkable.

An intellectual configuration has thus developed that revokes representation in favour of either a Platonic plain tale or a new art of the sublime, placed under the patronage of Burke and Kant. It pursues two lines. On the one hand, it argues for the internal impossibility of representation, the fact that a certain type of object leaves representation in ruins by shattering any harmonious relationship between presence and absence, between the material and the intelligible. This impossibility therefore appeals from the representative mode of art to a different kind of art. On the other hand, it argues for its indignity. It then places itself in a quite different framework – a Platonic ethical framework that does not involve the notion of art, but where what is judged is simply *images*, where what is examined is simply their relationship to their origin (are they worthy of what they represent?) and their destination (what effects do they produce on those who receive them?).

Thus, two logics become intertwined. The first concerns the distinction between different regimes of thinking about art – that is, different forms of the relationship between presence and absence, the material and the intelligible, exhibition and signification. The second does not involve art as such, but only different types of imitation, different types of image. The

intertwining of these two heterogeneous logics has a very precise effect: it transforms problems of the adjustment of representative distance into problems of the impossibility of representation. Proscription is then slipped into this impossibility, while being disclaimed, presented as a simple consequence of the properties of the object.

My aim is to understand this intertwining and try to disentangle it. In order to separate out the elements, I shall start with a straightforward case of unrepresentability – one involving an adjustment of representation. I have already had occasion to analyze the problems encountered by Corneille in composing his *Oedipe*. Sophocles' Oedipus was literally unrepresentable on the French stage for three reasons: the physical horror provoked by Oedipus's gouged-out eyes; a surplus of oracles, which anticipate the unfolding of the plot; and the absence of a love story.[1] I tried to show that what was involved was not merely the female sensitivities invoked by Corneille and the empirical relationship with the audience of his time. It concerns representation as such. It concerns *mimesis* as a relationship between two terms: a *poiesis* and an *aesthesis* – that is, a way of making and an economy of affects. The blinded eyes, the excessive obviousness of the oracles, and the absence of love interest pertain in effect to one and the same imbalance. On the one hand, there is a surplus of the visible, which is not subordinated to speech, which imposes itself. On the other hand, there is a surplus of the intelligible. The oracles say too much. There is too much knowledge – knowledge that arrives prematurely and overarches what the tragic action should only gradually unveil, through the operation of peripeteia. Between what is visible and what is intelligible there is a missing link, a specific type of interest capable of ensuring a suitable relationship between the seen and the

unseen, the known and the unknown, the expected and the unexpected; and also of adjusting the relationship of distance and proximity between stage and auditorium.

WHAT REPRESENTATION MEANS

This example helps us understand what *representation*, as a specific mode of art, means. The representative constraint is in effect threefold. It is first of all a dependency of the visible on speech. In it the essence of speech is to make seen, to order the visible by deploying a quasi-visibility wherein two operations are fused: an operation of substitution (which places 'before our eyes' what is removed in space or time) and an operation of exhibition (which makes what is intrinsically hidden from sight, the inner springs motivating characters and events, visible). Oedipus's blinded eyes are not merely a disgusting spectacle for ladies. They represent the brutal imposition in the field of vision of something that exceeds the subordination of the visible to the making-visible of speech. And this excess reveals the normal dual operation of representation. On the one hand, speech makes visible, refers, summons the absent, reveals the hidden. But this making-visible in fact operates through its own failing, its own restraint. This is the paradox explained by Burke in *A Philosophical Enquiry into the Origin of our Ideas of the Sublime and the Beautiful*. The descriptions of Hell and the angel of evil in *Paradise Lost* produce a sublime impression because they do not allow us to see the forms they evoke and affect to show us. Conversely, when painting renders the monsters that besiege St. Anthony's retreat visible to us, the sublime is transformed into the grotesque. This is because speech 'makes visible', but only in accordance with a regime of under-determination, by not 'really' making visible.

In its ordinary unfolding, representation employs this under-determination, while masking it. But the graphic representation of monsters or the exhibition of the blind man's gouged eyes brutally undoes this tacit compromise in speech between *making visible* and *not making visible*.

Corresponding to this adjustment of vision is a second adjustment, which concerns the relationship between knowing and not knowing, acting and suffering. This is the second aspect of the representative constraint. Representation is an ordered deployment of meanings, an adjusted relationship between what is understood or anticipated and what comes as a surprise, according to the paradoxical logic analyzed by Aristotle's *Poetics*. This logic of gradual, thwarted revelation excludes the abrupt emergence of speech that says too much, speaks too soon, and makes too much known. This is indeed what characterizes Sophocles's *Oedipus rex*. Aristotle makes it his model of the logic of dénouement through peripeteia and recognition. But this logic is itself caught up in a constant game of hunt the thimble with the truth. In it, Oedipus embodies the figure of the one who wants to know beyond the bounds of what is reasonable, who identifies knowledge with the unlimited character of his power. Now, this madness immediately marks Oedipus out as the only one whom the oracle and the blemish can concern. Confronting him there is, conversely, a character – Tiresias – who knows, who refuses to say what he knows, but nevertheless says it without saying it, and thus prompts in Oedipus a conversion of the desire to know into a refusal to hear.

Accordingly, prior to any ordered logic of peripeteia, we have an interaction between wanting to know, not wanting to say, saying without saying, and refusing to hear. A whole *pathos* of knowledge characterizes the ethical world of tragedy.

This is the world of Sophocles, but it is also the world of Plato
– one in which the point of mortals knowing things that are the
preserve of the Immortals is in question. This is the universe
from which Aristotle sought to extract tragedy. And in it lay
the construction of the order of representation: transferring
the ethical *pathos* of knowledge into a stable relationship
between a *poiesis* and an *aesthesis*; between an autonomous
arrangement of actions and the bringing into operation of
affects specific to the representative situation and it alone.

Now, Corneille believes that Aristotle did not succeed in this
endeavour. Oedipus's *pathos* of knowledge exceeds Aristotle's
plot of knowledge. There is an excess of knowledge that
thwarts the ordered unfolding of significations and revela-
tions. Correlatively, there is an excess of pathos that thwarts
the free operation of the spectator's affects. Corneille has
literally to deal with this unrepresentable thing. He therefore
strives to reduce it, to render the story and character repre-
sentable. To adjust the relationship between *mimesis*, *poiesis*
and *aesthesis*, he takes two negative steps and one positive
step. He places off-stage the undue visibility of the blinded
eyes, but also the excessive knowledge of Tiresias, whose
oracles are only reported. But above all, he subjects the *pathos*
of knowledge to a logic of action by palliating Sophocles's
third 'defect': the lack of love interest. He invents for Oedipus
a sister by the name of Dirce, daughter of Laius, who has been
deprived of the throne by the election of Oedipus. And he
invents a suitor for her, Theseus. Given that Theseus has
doubts about his parentage, and Dirce considers herself re-
sponsible for the voyage that cost her father his life, that makes
three real or potential children of Laius; three characters
whom the oracle might refer to; and, above all, according
to Corneille's logic, three people who dispute the honour

of that identification. The relationship between knowledge-effects and *pathos*-effects is thereby subjected to a specific form of intelligibility: the causal connection between actions. By identifying the two causalities which Aristotle separated – that of actions and that of characters – Corneille succeeds in reducing the ethical *pathos* of the tragedy to the logic of the dramatic action.

Thus, the 'empirical' issue of the audience and that of the autonomous logic of representation are linked. And this is the third aspect of the representative constraint. It defines a certain adjustment of reality. This takes the form of a dual accommodation. On the one hand, the entities of representation are fictional entities, exempt from any judgement of existence, and thus released from the Platonic question about their ontological consistency and ethical exemplariness. But these *fictional* beings are none the less *beings of resemblance*, beings whose feelings and actions must be shared and appreciated. The 'invention of actions' is both a boundary and a passage between two things: the events, at once possible and incredible, which tragedy links; and the recognizable and shareable feelings, volitions and conflicts of will that it offers the spectator. It is a boundary and passage between the enjoyment of suspense in fiction and the actual pleasure of recognition. And through this dual mechanism of distance and identification, it is also a boundary and passage between stage and auditorium. This relationship is not empirical. It is constitutive. The preferred site of representation is the theatre, a space of exhibition entirely given over to presence, but held by this very presence to a double restraint: the restraint of the visible under the sayable and of meanings and affects under the power of action – an action whose reality is identical to its unreality.

One author's difficulties with his subject therefore enable us to define a specific regime of art that exclusively merits the name of the representative regime. This system adjusts the relations between what can be seen and what can be said, between the unfolding of schemas of intelligibility and the unfolding of material manifestations. From it we may deduce that if there are things which cannot be represented, it is precisely in this regime. It is what defines compatibilities and incompatibilities in principle, conditions of receivability, and criteria of non-receivability. Thus it is that the character of Oedipus, although it satisfies in exemplary fashion the Aristotelian criterion of the prince who suffers reversals of fortune in accordance with a paradoxical logical sequence, proves 'unrepresentable' for Corneille, because it distorts the system of relations that defines, more fundamentally, the representative order itself.

But such unrepresentability is doubly relative. It is relative to the representative order, but it is also relative to the very heart of this order. If Oedipus's character and actions are inappropriate, they can be changed. And this is what Corneille does, by inventing a new fictional logic and new characters. This not only makes Oedipus representable. It makes this representation a masterpiece of representative logic. The audience, Corneille tells us, reckoned that of his tragedies it was the one which contained the most art. In fact, none of the others offers such a perfect combination of inventions aimed at integrating something that did not fall within the representative framework into it.

The result is that this tragedy is never staged today. Not by chance, but precisely because of this excess of art, this perfection of a certain art and the presupposition that grounds it. This presupposition is that some subjects are suitable for

artistic presentation, while others are not; that some are appropriate for a particular artistic genre, while others are inappropriate. And it is also the presupposition that a series of changes can be made which render the inappropriate subject appropriate and establish the appropriateness that was wanting. The whole art of Corneille's *Oedipe* rests on this dual presupposition. If his play is no longer staged, it is because our perception of art has, since Romanticism, rested on strictly converse presuppositions that define not a particular school or sensibility, but a new regime of art.

WHAT ANTI-REPRESENTATION MEANS

In this new regime, there are no longer appropriate subjects for art. As Flaubert put it, 'Yvetot is as good as Constantinople' and the adulteries of a farmer's daughter are as good as those of Theseus, Oedipus or Clytemnestra. There are no longer rules of appropriateness between a particular subject and a particular form, but a general availability of all subjects for any artistic form whatsoever. On the other hand, there are certain characters and certain stories that cannot be altered at will, because they are not simply available 'subjects', but founding myths. Yvetot and Constantinople can be rendered equivalent, but one cannot do anything one likes with Oedipus. For the mythical figure of Oedipus, which encapsulates everything the representative regime rejected, is emblematic of all the properties that the new regime of art – the *aesthetic* regime – attributes to artistic phenomena. What in fact is the 'disorder' of Oedipus, which ruined the balanced distribution of knowledge-effects and *pathos*-effects specific to the representative regime of art? It consists in the fact that he is the one who knows and does not know, who acts absolutely

and suffers absolutely. It is precisely this double identity of opposites that the aesthetic revolution counter-poses to the representative model, by subsuming artistic phenomena under the new concept of aesthetics. On the one hand, it counter-poses to the norms of representative action an absolute power of *making* on the part of the artwork, pertaining to its own law of production and self-demonstration. But on the other, it identifies the power of this unconditioned production with absolute passivity. This identity of opposites is summarized in Kant's theory of genius. Genius is the active power of nature, opposed to any norm, which is its own norm. But a genius is also someone who does not know what he is doing or how he does it. What is deduced from this in Schelling and Hegel is a conceptualization of art as the unity of a conscious process and an unconscious process. The aesthetic revolution establishes this identity of knowledge and ignorance, acting and suffering, as the very definition of art. In it the artistic phenomenon is identified as the identity, in a physical form, of thought and non-thought, of the activity of a will that wishes to realize its idea and of a non-intentionality, a radical passivity of material being-there. Oedipus is quite naturally the hero of this regime of thinking, which identifies artistic phenomena as intellectual phenomena in as much as they are modes of a thought that is immanent in its other and inhabited by its other in turn.

The opposite of the representative regime in art is thus not a regime of non-representation, in the sense of non-figuration. A convenient tale identifies the anti-representative break as a transition from realism of representation to non-figuration: a form of painting that no longer offers resemblances, a literature that has wrested its intransitive character from the language of communication. It thus aligns the anti-representative revolution with some general destiny of 'modernity', either by

identifying the latter with the positive principle of a generalized autonomy which anti-figurative emancipation forms part of; or by identifying it with the negative phenomenon of a loss of experience, of which the retreat from figuration is the inscription.

This fable is convenient, but it is inconsistent. For the representative regime in art is not one in which art's task is to fashion resemblances. It is a regime in which resemblances are subject to the triple constraint that we have noted: a model of visibility of speech that at the same time organizes a certain restraint of the visible; an adjustment of the relations between knowledge-effects and *pathos*-effects, governed by the primacy of the 'action', identifying the poem or painting with a story; and a regime of rationality peculiar to fiction, which exempts its speech acts from the normal criteria of authenticity and utility of words and images, subjecting them instead to intrinsic criteria of verisimilitude and appropriateness. This separation between the rationale of fictions and the rationale of empirical facts is one of the representative regime's main elements.

We can deduce from this that the break with representation in art is not emancipation from resemblance, but the emancipation of resemblance from that triple constraint. In the anti-representative break, pictorial non-figuration is preceded by something seemingly quite different: novelistic realism. But what is novelistic realism? It is the emancipation of resemblance from representation. It is the loss of representative proportions and proprieties. Such is the disruption that critics of Flaubert denounced at the time under the heading of realism: everything is now on the same level, the great and the small, important events and insignificant episodes, human beings and things. Everything is equal, equally representable.

And this 'equally representable' spells the ruin of the representative system. Contrasting with the representative scene of visibility of speech is an equality of the visible that invades discourse and paralyzes action. For what is newly visible has very specific properties. It does not make visible; it imposes presence. But this presence is itself singular. On the one hand, speech is no longer identified with the gesture that makes visible. It exhibits its particular opacity, the under-determined character of its power to 'make visible'. And such under-determination becomes the very mode of material presentation specific to art. At the same time, however, speech is invaded by a specific property of the visible: its passivity. The performance of speech is struck by this passivity, this inertia of the visible that comes to paralyze action and absorb meanings.

This is the change at stake in the controversy over description in the nineteenth century. The new novel – the novel called realist – is criticized for a primacy of description over action. The primacy of description is in fact that of a form of the visible which does not make visible, which deprives action of its powers of intelligibility – that is, of its powers of ordered distribution of knowledge-effects and *pathos*-effects. This power is absorbed by the apathetic *pathos* of description that merges wills and meanings in a succession of little perceptions where activity and passivity can no longer be distinguished. Aristotle contrasted the *kath'olon* – the organic totality – of poetic plot to the *kath'ekaston* of the historian, who follows the empirical succession of events. In the 'realist' use of resemblance, this hierarchy is overturned. The *kath'olon* is absorbed into the *kath'ekaston*, absorbed into little perceptions, each of which is affected by the power of the whole, in as much as in each the power of inventive, signifying thought is equal to the passivity of sensation. Thus the novelistic realism regarded by

some as the acme of representative art is quite the opposite. It is the revocation of representative mediations and hierarchies. In their stead, a regime of immediate identity between the absolute decision of thought and pure factuality is established.

Likewise retracted therewith is the third major aspect of representative logic – the one that assigns a specific space to representation. An emblematically entitled prose poem by Mallarmé might be taken to symbolize it. 'Le spectacle inter-rompu' presents us with the exhibition of a dancing bear by a clown, which is disrupted by an unforeseen incident: the up-right bear puts his paws on the clown's shoulders. Around this incident, which the clown and the audience experience as a threat, the poet/spectator composes his poem: in this clinch of bear and clown he perceives a question addressed by the animal to the human being about the secret of his power. And he makes it the very emblem of the relationship between the auditorium and the stage, where the animal's pantomime is elevated to the stellar grandeur of his namesake, the Great Bear. This 'accident of representation' functions as an emblem of the aesthetic revocation of the representative regime. The 'interrupted spectacle' revokes the privilege of the theatrical space of visibility, the separate space where representation offered itself up to vision as a specific activity. Now there is poetry anywhere and everywhere – in the attitude of a bear, the flick of a fan, or the movement of a head of hair. There is poetry wherever some spectacle can symbolize the identity of what is thought and what is not thought, what is wanted and what is not wanted. What is revoked, at the same time as the poem's specific space of visibility, is the representative separa-tion between the rationale of facts and the rationale of fictions. The identity of the wanted and the unwanted can be located anywhere. It rejects the separation between a specific world of

facts pertaining to art and a world of ordinary facts. Such is the paradox of the aesthetic regime in the arts. It posits the radical autonomy of art, its independence of any external rule. But it posits it in the same gesture that abolishes the mimetic closure separating the rationale of fictions from that of facts, the sphere of representation from other spheres of existence.

In an artistic regime of this kind, what substance and meaning might the notion of the unrepresentable possess? It can mark the difference between two regimes of art, the withdrawal of artistic phenomena from the system of representation. But it cannot signify, as it did in that regime, that there are events and situations which are excluded in principle from the adequate connexion of a process of exhibition and a process of signification. Indeed, subjects in it are no longer submitted to the representative adjustment of the visibility of speech, no longer subject to the identification of the process of signification with the construction of a story. We can, if we wish, summarize this in a formula of Lyotard's, when he refers to a 'failing of the stable adjustment between the perceptible and the intelligible'. But this 'failing' precisely signifies an exit from the representative universe – that is, from a universe defining criteria of unrepresentability. If there is a failing of the representative adjustment, it means, contrary to Lyotard, that exhibition and signification can be harmonized *ad infinitum*, that their point of agreement is everywhere and nowhere. It lies wherever an identity between meaning and non-meaning can be made to coincide with an identity between presence and absence.

THE REPRESENTATION OF THE INHUMAN

Now, this possibility knows no objects that infirm it on account of their particular singularity. And it has proved

perfectly suited to the representation of phenomena that are said to be unrepresentable – concentration camps and extermination camps. I would like to show this by deliberately taking two very well-known examples of works devoted to the horror of the camps and the extermination. I take the first from the beginning of Robert Antelme's *The Human Race*:

> I went outside to take a piss. It wasn't yet daylight. Beside me others were pissing too; nobody spoke. Behind the place where we pissed was the trench to shit in; other guys were sitting on the little wall above it, their pants down. The trench was covered by a small roof, but not the urinal. Behind us there were sounds of galoshes, of coughing; that came from the others who were arriving. The latrines were never deserted. A steam floated above the urinals at all hours . . . Nights were calm at Buchenwald. The huge machine of the camp would go to sleep. From time to time, searchlights came on on the watchtowers: the eyes of the SS would open, would close. In the woods that hemmed in the camp patrols made their rounds. Their dogs did not bark. For the sentinels time went quietly by.[2]

This is commonly regarded as a form of writing that corresponds to a specific experience – the experience of a life reduced to its most basic aspects, stripped of any horizon of expectations, and merely connecting simple actions and perceptions one after the other. Corresponding to this experience is the paratactic linking of simple perceptions. And the writing evinces the specific form of resistance that Robert Antelme wants to highlight: the one that transforms the concentration camp's reduction of life to naked existence into the affirmation of fundamental membership of the human race, even in its most basic gestures. Yet it is clear that this paratactic writing is not born out of the camp experience. It is

also the style of writing of Camus's *L'Étranger* and the American behaviourist novel. To go back further, it is the Flaubertian writing style of small perceptions placed side by side. The nocturnal silence of the camps reminds us in fact of other silences – those that characterize amatory moments in Flaubert. I propose to hear the echo of one of the moments that mark the meeting of Charles and Emma in *Madame Bovary*:

> She sat down again and resumed her work, a white cotton stocking that she was darning. She worked with her head lowered. She did not speak, neither did Charles. The draught beneath the door blew a little dust over the flagstones, and he watched it creep along. He could hear nothing but the throbbing inside his head and the cackle of a laying hen somewhere away in the farmyard.[3]

Doubtless the subject is more trivial and the language more basic in Robert Antelme than in Flaubert (even so, it is remarkable that the first line of this urinal scene and of the book itself is an Alexandrine: *Je suis allé pisser; il faisait encore nuit*). Here Flaubert's paratactic style becomes, if I can put it like this, a paratactic syntax. But this story of waiting before the departure of the convoy is based on the same relationship between exhibition and signification; the same regime of rarefaction is found in both. The concentration camp experience as lived by Robert Antelme, and the invented sensory experience of Charles and Emma, are conveyed according to the same logic of minor perceptions added to one another, which make sense in the same way, through their silence, through their appeal to a minimal auditory and visual experience (the sleeping machine and the dozing farmyard; the dogs that do not bark and the cackle of hens in the distance).

Thus Robert Antelme's experience is not 'unrepresentable' in the sense that the language for conveying it does not exist. The language exists and the syntax exists. Not as an exceptional language and syntax, but, on the contrary, as a mode of expression peculiar to the aesthetic regime in the arts in general. The problem is in fact rather the reverse. The language that conveys this experience is in no way specific to it. The experience of a programmed de-humanization quite naturally finds itself expressed in the same way as the Flaubertian identity between the human and the inhuman, between the emergence of an emotion uniting two beings and a little dust stirred up by a draught in a farm kitchen. Antelme wants to convey a lived, incomparable experience of the parcelling out of experience. Yet the language he selects for its appropriateness to this experience is the common language of literature in which the absolute freedom of art has, for a century, been identified with the absolute passivity of physical matter. This extreme experience of the inhuman confronts no impossibility of representation; nor is there a language peculiar to it. There is no appropriate language for witnessing. Where testimony has to express the experience of the inhuman, it naturally finds an already constituted language of becoming-inhuman, of an identity between human sentiments and non-human movements. It is the very language whereby *aesthetic* fiction is opposed to *representative* fiction. And one might at a pinch say that the unrepresentable is lodged precisely here, in the impossibility of an experience being told in its own appropriate language. But this principled identity of the appropriate and the inappropriate is the very stamp of the aesthetic regime in art.

This is what a different example, taken from a significant work, indicates. I am thinking here of the beginning of Claude

Lanzmann's *Shoah*, a film around which a whole discourse of the unrepresentable or of the interdiction of representation nevertheless floats. But in what sense does this film attest to some 'unrepresentability'? It does not claim that the fact of extermination is removed from artistic presentation, from the production of an artistic equivalent. It only denies that such an equivalent can be provided by a fictional embodiment of the executioners and the victims. For what is to be represented is not executioners and victims, but the process of a double elimination: the elimination of the Jews and the elimination of the traces of their elimination. This is perfectly representable. Only it is not representable in the form of fiction or testimony which, by bringing the past 'back to life', renounces representing the second elimination. That is representable in the form of a specific dramatic action, as announced by the film's opening provocative sentence: 'The action starts in our time . . .'. If what has occurred, and of which nothing remains, can be represented, it is through an action, a newly created fiction which begins in the here and now. It is through a confrontation between the words uttered here and now about what was and the reality that is materially present and absent in this place.

But this confrontation is not restricted to the negative relationship between the content of the testimony and the emptiness of the place. The whole first episode of Simon Srebnik's testimony in the clearing of Chelmno is constructed according to a much more complex mechanism of resemblance and dissemblance. Today's scene resembles yesterday's extermination through the same silence, the same tranquillity of the place, by the fact that today, while the film is being shot, as yesterday, when the killing machine was functioning, everyone is quite simply at their post, not speaking of what they are

doing. But this resemblance lays bare the radical dissemblance, the impossibility of adjusting today's tranquillity to yesterday's. The inadequacy of the deserted site to the words that fill it imparts an hallucinatory quality to the resemblance. This sense, expressed in the mouth of the witness, is communicated differently to the viewer by the framing shots that present him as a miniscule figure in the middle of the enormous clearing. The impossibility of adequate correspondence between the place and the speech and very body of the witness goes to the heart of the elimination that is to be represented. It touches the incredible character of the event, programmed by the very logic of the extermination – and confirmed by negationist logic: *even if one of you survives to bear witness, no one will believe you* – that is to say, *no one will believe in the filling of this void by what you will say; it will be regarded as an hallucination.* This is what the speech of the witness framed by the camera responds to. It avows the incredible, the hallucinatory, the impossibility that words could fill this empty place. But it reverses their logic. It is the *here and now* that is stamped by hallucination, incredulity: 'I don't believe I'm here', says Simon Srebnik. The reality of the Holocaust that is filmed is indeed then the reality of its disappearance, the reality of its incredible character. The reality of the incredible is stated by the speech of the witness in this interplay of resemblance/ dissemblance. The camera has him pace up and down the enormous clearing as a tiny figure. It thus makes him measure time and the incommensurable relationship between what speech says and what the place attests to. But this measuring of the incommensurable and the incredible is itself not possible without a trick of the camera. Reading the historians of the extermination who provide us with its exact dimensions, we learn that the clearing of Chelmno was not as huge as that.[4]

The camera has had to magnify it subjectively to mark the lack of proportion, to fashion action commensurate with the event. It has had to use special effects when representing the place in order to account for the reality of the extermination and the erasure of its traces.

This brief example indicates that *Shoah* only poses problems of comparative representability, of adaptation of the means and ends of representation. If one knows what one wants to represent – i.e., in the case of Claude Lanzmann, the reality of the incredible, the equivalence of the real and the incredible – there is no property of the event that proscribes representation, that proscribes art, in the precise sense of artifice. Nothing is unrepresentable as a property of the event. There are simply choices. The choice of the present as against historicization; the decision to represent an accounting of the means, the materiality of the process, as opposed to the representation of causes. The causes that render the event resistant to any explanation by a principle of sufficient reason, be it fictional or documentary, must be left on hold.

But respecting such suspension is not in any way opposed to the artistic means at Lanzmann's disposal. It is in no way opposed to the logic of the aesthetic regime in the arts. To investigate something that has disappeared, an event whose traces have been erased, to find witnesses and make them speak of the materiality of the event without cancelling its enigma, is a form of investigation which certainly cannot be assimilated to the representative logic of verisimilitude that led to Corneille's *Oedipe* being recognized as guilty. On the other hand, it is perfectly compatible with the relationship between the truth of the event and fictional invention specific to the aesthetic regime in the arts. And Lanzmann's investigation is part of a cinematic tradition that has established its pedigree.

This is the tradition that counter-poses to the light thrown on the blinding of Oedipus the simultaneously solved and unresolved mystery of Rosebud, which is the 'reason' for Kane's madness, the revelation at the end of the investigation, beyond investigation, of the nullity of the 'cause'. According to the logic specific to the aesthetic regime, this form/investigation abolishes the boundary between the connection of fictional facts and that of real events. This is why the Rosebud schema has recently been able to serve in a 'documentary' film like *Reprise*, for an investigation aimed at tracking down the female worker in the minor 1968 documentary film on the resumption of work at the Wonder factory. A form of investigation that reconstructs the materiality of an event, while leaving its cause on hold, proves suitable to the extraordinary character of the Holocaust without being specific to it. Here again the appropriate form is also an inappropriate form. In and of itself the event neither prescribes nor proscribes any artistic means. And it does not impose any duty on art to represent, or not to represent, in some particular way.

THE SPECULATIVE HYPERBOLE
OF THE UNREPRESENTABLE

Thus, the 'failing of the stable relationship between the perceptible and the intelligible' might perfectly well be construed as the unlimited character of the powers of representation. In order to interpret it in the sense of the 'unrepresentable', and posit certain events as unrepresentable, a double subreption has to be made – one involving the concept of event, the other the concept of art. This double subreption is what is presented in Lyotard's construction of a coincidence between something unthinkable at the heart of the event and something unpre-

sentable at the heart of art. *Heidegger and 'The Jews'* creates a parallel between the immemorial fate of the Jewish people and the anti-representative modern destiny of art. Both similarly attest to an original poverty of mind. This is only set in motion when moved by an original terror, an initial shock that transforms it into a hostage of the Other, that unmasterable other which, in the individual psyche, is simply called the primary process. The unconscious affect, which not only penetrates the mind but literally opens it, is the stranger in the house, always forgotten, and whose mind must even forget this forgetting in order to be able to pose as master of itself. In the Western tradition, this Other has supposedly assumed the name of the Jew, the name of the people that is witness to forgetfulness, witness to the original condition of thinking which is hostage of the Other. It follows that the extermination of the Jews is inscribed in the project of self-mastery of Western thought, in its will to have done with the witness of the Other, the witness of what is unthinkable at the heart of thought. This condition is supposedly comparable to the modern duty of art. The construction of this duty in Lyotard causes two heterogeneous logics to overlap: an intrinsic logic of the possibilities and impossibilities specific to a regime of art and an ethical logic of denunciation of the very phenomenon of representation.

 In Lyotard this overlap is created by the simple identification of the divide between two regimes in art with the distinction between an aesthetic of the beautiful and an aesthetic of the sublime. 'With the aesthetic of the sublime,' Lyotard writes in *The Inhuman*, 'what is at stake in the arts is their making themselves witness to the fact that there are things which are *indeterminate*.' Art supposedly makes itself the witness to the 'it happens' which always occurs before its nature, its *quid* can be grasped; witness to the fact that there is something

unpresentable at the heart of thought which wishes to give itself material form. The fate of the avant-gardes is to attest to this unpresentability that seizes hold of thought, to inscribe the shock of the material, and testify to the original gap.

How is the idea of sublime art constructed? Lyotard refers to Kant's analysis of the powerlessness of the imagination which, faced with certain spectacles, feels itself carried off beyond its domain, led to see in the sublime spectacle – what is called sublime – a negative presentation of the ideas of reason that elevate us above the phenomenal order of nature. These ideas manifest their sublimity by the powerlessness of the imagination to create a positive presentation of them. Kant compares this negative presentation with the sublimity of the Mosaic command 'Thou shalt not make graven images'. The problem is that he does not derive from it any idea of a sublime art attesting to the gap between Idea and material presentation. The idea of the sublime in Kant is not the idea of a kind of art. It is an idea that draws us outside the domain of art, transferring us from the sphere of aesthetic play to that of the ideas of reason and practical freedom.

The problem of 'sublime art' is thus posed in simple terms: one cannot have sublimity both in the form of the command-ment prohibiting the image and in the form of an image witnessing to the prohibition. To resolve the problem, the sublime character of the commandment prohibiting the image must be identified with the principle of a non-representative art. But in order to do that, Kant's extra-artistic sublime has to be identified with a sublime that is defined within art. This is what Lyotard does when he identifies Kant's moral sublime with the poetic sublime analyzed by Burke.

What, for Burke, did the sublimity of the portrait of Satan in *Paradise Lost* consist in? In the fact that it brought together

'images of a tower, an archangel, the sun rising through mists, or in an eclipse, the ruin of monarchs, and the revolutions of kingdoms'.[5] This accumulation of images creates a sense of the sublime by virtue of its multiplicity and disorder – that is, through the under-determination of the 'images' proposed by the words. There is, Burke noted, an affective power to words that is communicated directly to the mind, short-circuiting material presentation in images. The counter-proof of this is provided when pictorial visualization transforms the poem's sublime 'images' into grotesque imagery. Such sublimity is therefore defined on the basis of the very principles of representation and, in particular, the specific properties of the 'visibility of speech'. Now, in Lyotard this under-determination – this loose relationship between the visible and the sayable – is taken to a limit where it becomes the Kantian indeterminacy of the relationship between idea and material presentation. The collage of these two 'sublimes' makes it possible to construct the idea of sublime art conceived as a negative presentation, testimony to the Other that haunts thought. But this indetermination is, in reality, an over-determination: what arrives in the place of representation is in fact the inscription of its initial condition, the trace of the Other that haunts it displayed.

This is the price for an alignment of two sets of testimony, of two 'duties to witness'. Sublime art is what resists the imperialism of thought forgetful of the Other, just as the Jewish people is the one that remembers the forgetting, which puts at the basis of its thought and existence this founding relationship to the Other. The extermination is the end-point of the process of a dialectical reason concerned to cancel from its core any alterity, to exclude it and, when it is a people, to exterminate it. Sublime art is then the contemporary witness of this planned

death and its implementation. It attests to the unthinkability of the initial shock and the unthinkable project of eliminating this unthinkability. It does it by testifying not to the naked horror of the camps, but to the original terror of the mind which the terror of the camps wishes to erase. It bears witness not by representing heaps of bodies, but through the orange-coloured flash of lightning that traverses the monochrome of a canvas by Barnett Newman, or any other procedure whereby painting carries out an exploration of its materials when they are diverted from the task of representation.

But Lyotard's schema does quite the opposite of what it claims to do. It argues for some original unthinkable phenomenon resistant to any dialectical assimilation. But it itself becomes the principle of a complete rationalization. In effect, it makes it possible to identify the existence of a people with an original determination of thought and to identify the professed unthinkability of the extermination with a tendency constitutive of Western reason. Lyotard radicalizes Adorno's dialectic of reason by rooting it in the laws of the unconscious and transforming the 'impossibility' of art after Auschwitz into an art of the unpresentable. But this perfecting is ultimately a perfecting of the dialectic. What is assigning a people the task of representing a moment of thought, and identifying the extermination of this people with a law of the psychic apparatus, if not a hyperbolic version of the Hegelian operation that makes the moments of the development of spirit – and forms of art – correspond to the concrete historical figures of a people or a civilization?

It will be said that this attribution is a way of disrupting the machine. It involves halting the dialectic of thought at the point where it is in the process of plunging in. On the one hand, however, the plunge has already been taken. The event has

occurred and this having-happened is what authorizes the discourse of the unthinkable-unrepresentable. On the other hand, we can query the genealogy of this sublime art, anti-dialectical witness to the unpresentable. I have said that Lyotard's sublime was the product of a singular montage between a concept of art and a concept of what exceeds art. But this montage, which confers on sublime art the task of witnessing to what cannot be represented, is itself highly determinate. It is precisely the Hegelian concept of the sublime, as the extreme moment of symbolic art. In Hegel's conceptualization of it, the peculiarity of symbolic art is that it is unable to find a mode of material presentation for its idea. The idea of divinity that inspires Egyptian art cannot hit upon an adequate image in the stone of the pyramids or colossal statues. This failing of positive presentation becomes a success of negative presentation in sublime art, which conceives the non-figurable infinity and alterity of the divinity and, in the words of the Jewish 'sacred poem', states this unrepresent-ability, this distance of divine infinity from any finite presen-tation. In short, the concept of art summoned to disrupt the Hegelian machine is none other than the Hegelian concept of the sublime.

In Hegel's theorization, there is not one moment of symbolic art but two. There is the symbolic art prior to representation. And there is the new symbolic moment that arrives at the end, after the representative era in art, at the end of the Romantic dissociation between content and form. At this extreme point, the interiority that art wishes to express no longer has any form of determinate presentation. The sublime then returns, but in a strictly negative form. It is no longer the simple impossibility of a substantial thought finding adequate mate-rial form. It is the empty infinitization of the relationship

between the pure will to art and the things – which can be anything – in which it asserts itself and contemplates its reflection. The polemical function of this Hegelian analysis is clear: it aims to reject the notion that another art might be born out of the dissolution of the determinate relationship between idea and material presentation. For Hegel such dissolution can only signify the end of art, a state beyond art. The peculiarity of Lyotard's operation is to reinterpret this 'beyond', to transform the bad infinity of an art reduced to reproducing solely its signature into a fidelity to an original debt. But sublime unrepresentability then confirms Hegel's identification between a moment of art, a moment of thought, and the spirit of a people. The unrepresentable paradoxically becomes the ultimate form in which three speculative postulates are preserved: the idea of a correspondence between the form and the content of art; the idea of a total intelligibility of the forms of human experience, including the most extreme; and, finally, the idea of a correspondence between the explanatory reason of events and the formative reason of art.

I shall conclude briefly with my opening question. Some things are unrepresentable as a function of the conditions to which a subject of representation must submit if it is to be part of a determinate regime of art, a specific regime of the relations between exhibition and signification. Corneille's *Oedipe* provided us with an example of maximum constraint, a determinate set of conditions defining the properties that subjects of representation must possess to permit an adequate submission of the visible to the sayable; a certain type of intelligibility concentrated in the connection of actions and a well-adjusted division of proximity and distance between the representation and those to whom it is addressed. This set of conditions exclusively defines the representative regime in art, the regime

of harmony between *poesis* and *aesthesis* disrupted by the Oedipal *pathos* of knowledge. If there are things which are unrepresentable, they can be located in this regime. In our regime – the aesthetic regime in art – this notion has no determinable content, other than the pure notion of discrepancy with the representative regime. It expresses the absence of a stable relationship between exhibition and signification. But this maladjustment tends towards more representation, not less: more possibilities for constructing equivalences, for rendering what is absent present, and for making a particular adjustment of the relationship between sense and non-sense coincide with a particular adjustment of the relationship between presentation and revocation.

Anti-representative art is constitutively an art without unrepresentable things. There are no longer any inherent limits to representation, to its possibilities. This boundlessness also means that there is no longer a language or form which is appropriate to a subject, whatever it might be. This lack of appropriateness runs counter both to credence in a language peculiar to art and to the affirmation of the irreducible singularity of certain events. The assertion of unrepresentability claims that some things can only be represented in a certain type of form, by a type of language appropriate to their exceptionality. *Stricto sensu*, this idea is vacuous. It simply expresses a wish: the paradoxical desire that, in the very regime which abolishes the representative suitability of forms to subjects, appropriate forms respecting the singularity of the exception still exist. Since this desire is contradictory in principle, it can only be realized in an exaggeration which, in order to ensure the fallacious equation between anti-representative art and an art of the unrepresentable, places a whole regime of art under the sign of holy terror. I have tried to show that this

exaggeration itself merely perfects the system of rationalization it claims to denounce. The ethical requirement that there should be an art appropriate to exceptional experience dictates exaggeration of the forms of dialectical intelligibility against which the rights of the unrepresentable are supposedly being upheld. In order to assert an unrepresentability in art that is commensurate with an unthinkability of the event, the latter must itself have been rendered entirely thinkable, entirely necessary according to thought. The logic of the unrepresentable can only be sustained by a hyperbole that ends up destroying it.

Notes

1 THE FUTURE OF THE IMAGE

1 Editorial note: *Au hasard Balthazar* (1966) is a film directed by Robert Bresson, revolving around the fate of a donkey, Balthazar. *Questions pour un champion* is a popular television general knowledge quiz show, based on the British show *Going for Gold*, and shown on the channel France 3.

2 Régis Debray, *Vie et mort de l'image*, Gallimard, Paris 1992, p. 382.

3 Roland Barthes, *Camera Lucida*, trans. Richard Howard, Flamingo, London 1984, p. 80.

4 See Denis Diderot, *Oeuvres completes*, Le Club français du livre, Paris 1969, volume two, pp. 554–5, 590–601.

5 Stéphane Mallarmé, 'Richard Wagner. Rêverie d'un poète français', in *Divagations*, Gallimard, Paris 1976, p. 170.

6 Cf. Clément Chéroux, ed., *Mémoires des camps. Photographies des camps de concentration et d'extermination nazis (1933–1945)*, Marval 2001 (the photograph is reproduced on p. 123).

7 See Serge Daney, 'L'arrêt sur image', in *Passages de l'image*, Centre Georges Pompidiou, Paris 1990 and *L'Exercice a été profitable, Monsieur*, P.O.L., Paris 1993, p. 345.

8 Thierry de Duve, *Voici, cent ans d'art contemporain*, Ludion/Flammarion, Paris 2000, pp. 13–21.

9 See Jacques Rancière, *La Fable cinématographique*, Seuil, Paris 2001, pp. 218–22.

2 SENTENCE, IMAGE, HISTORY

1 The exhibition *Sans commune mesure*, curated by Régis Durand, occurred in September–December 2002, in three separate sites: the Centre National de la Photographie – where this text was delivered – the Musée d'art moderne de Villeneuve d'Ascq, and the Studio national des arts contemporains de Fresnay.

2 Michel Foucault, 'The Discourse on Language', trans. Rupert Swyer, in *The Archaeology of Knowledge*, Pantheon, New York 1972.

3 Louis Althusser, *For Marx*, trans. Ben Brewster, Allen Lane, London 1969, p. 151.

4 Editorial note: a *charcuterie* is a shop, rather like a delicatessen, where a variety of meat products – also called *charcuterie* – such as pâté, salami, blood pudding and so forth are sold.

5 Blaise Cendrars, 'Aujourd'hui', *Oeuvres complètes*, vol. 4, Seghers, Paris 1974, pp. 144–5, 162–6.

6 Jean Epstein, 'Bonjour cinéma', in *Oeuvres complètes*, Seghers, Paris 1974, volume one, pp. 85–102.

7 Cf., in particular, Flaubert's letter to Mademoiselle Leroyer de Chantepie of 12 December 1857 and the letter to George Sand of March 1876.

8 Sergei Eisenstein, 'Les vingt piliers de soutènement', in *La non-indifférente nature*, 10/18, Paris 1976, pp. 141–213.

9 I am grateful to Bernard Eisenschitz for identifying these elements.

10 Cf. Louis Aragon, *Le Paysan de Paris*, Gallimard, Paris 1966, pp. 29–33.

11 Foucault, 'The Discourse on Language', p. 215. Cf. Althusser on the same theme of the sentence that has already begun: 'I look back, and I am suddenly and irresistibly assailed by *the* question: are not these few pages, in their maladroit and groping way, simply that unfamiliar play *El Nost Milan*, performed on a June evening, pursuing me in its incomplete meaning, searching in me, despite myself, now that all the actors and sets have been cleared away, for the *advent* of its silent discourse?' (*For Marx*, p. 151).

12 See Elie Faure, *Histoire de l'art*, Le Livre de Poche, Paris 1976, volume four, pp. 167–83.

13 See *La Fable cinématographique*.

3 PAINTING IN THE TEXT

1 Clement Greenberg, 'Modernist Painting', in Charles Harrison and Paul Wood, *Art in Theory 1900–1990: An Anthology of Changing Ideas*, Blackwell, Oxford and Cambridge 2001, pp. 754–60 (here p. 756).

2 Denis Diderot, 'Le Salon de 1769', in *Oeuvres complètes*, Le Club français du livre, Paris 1969, volume eight, p. 449.

3 See *Hegel's Aesthetics: Lectures on Fine Art*, trans. T. M. Knox, Clarendon Press, Oxford 1998, volume one, pp. 168–9, 597–600 and volume two, pp. 885–7.

4 Marcel Proust, 'Within a Budding Grove', in *Remembrance of Things Past*, volume one, trans. C. K. Scott Moncrieff and Terence Kilmartin, Penguin, Harmondsworth 1983, p. 893.

5 Edmond and Jules Goncourt, *French Eighteenth-Century Painters*, trans. Robin Ironside, Phaidon, Oxford 1981, pp. 115–17.

6 G. Albert Aurier, *Le Symbolisme en peinture*, L'Échoppe, Paris 1991, pp. 15–16.

4 THE SURFACE OF DESIGN

1 The bases of the thinking of the *Werkbund* and Behrens are analyzed in Frederic J. Schwartz's book *The Werkbund: Design Theory and Mass Culture before the First World War*, Yale University Press, New Haven 1996.

5 ARE SOME THINGS UNREPRESENTABLE?

1 See Jacques Rancière, *L'inconscient esthétique*, Galilée, Paris 2001.

2 Robert Antelme, *The Human Race*, trans. Jeffrey Haight and Annie Mahler, The Marlboro Press, Marlboro (Vermont) 1992, pp. 9–10.

3 Gustave Flaubert, *Madame Bovary*, trans. Allan Russell, Penguin, Harmondsworth 1950, p. 35.

4 We also have a sense of this in Pascal Kané's film *La Théorie du fantôme*, in which the director finds the place where several members of his family disappeared.

5 Edmund Burke, *A Philosophical Enquiry into the Sublime and the Beautiful and Other Pre-Revolutionary Writings*, ed. David Womersley, Penguin, London 1999, pp. 105–06.

Index